"A collection of stories to make you laugh, cry, cheer—Schimel takes fantasy to queer places it's never gone before."

—Robin Wayne Bailey, author of *Shadowdance*

"Lawrence Schimel gleefully subverts the cliches of genre fantasy, and the verities of myth and religion, with stories that playfully illuminate surprising corners of gay, queer, and lesbian life."

—Mark Kelly, *Locus* Magazine

"The title story alone is worth the price of the book. Read and enjoy!"

—Nancy Springer, author of *Larque on the Wing*

The Drag Queen
of Elfland
and
Other Stories

by
Lawrence Schimel

The Drag Queen of Elfland

Circlet Press, Inc.
1770 Massachusetts Avenue, #278
Cambridge, MA 02140
circlet-info@circlet.com
http://www.circlet.com/circlet/home.html

Typeset and printed in the United States of America
Text design and typesetting by Swordsmith Productions

ISBN 1-885865-17-1

First Printing: June 1997

The Ultra Violet Library is an imprint of Circlet Press.

Circlet Press is distributed in the USA and Canada by the LPC Group.
Circlet Press is distributed in the UK and Europe by Turnaround Ltd.

For Bruce Coville

Other Books by Lawrence Schimel

*Switch Hitters: Lesbians Write Gay Male Erotica
and Gay Men Write Lesbian Erotica*
(with Carol Queen)

Food for Life and Other Dish

Two Hearts Desire: Gay Couples on Their Love
(with Michael Lassell)

Tarot Fantastic
(with Martin H. Greenberg)

The Fortune Teller
(with Martin H. Greenberg)

*PoMoSEXUALS:
Challenging Assumptions About Gender and Sexuality*
(with Carol Queen)

The Mammoth Book of Gay Erotica

Yankee Vampires
(with Martin H. Greenberg)

Dixie Vampires
(with Martin H. Greenberg)

Boy Meets Boy

Vampires of the Heartland
(with Martin H. Greenberg)

New York Vampires
(with Martin H. Greenberg)

Acknowledgments

This book is my own creation and I am responsible for all its faults. But there are some people who are partly responsible for some of the things that are right with it, and I'd like to thank some of them here.

Special thanks go to Richard Labonté and to Ron McCutchan, for their friendship and their invaluable advice on the manuscript. Also to Allison Miller, especially for "Heart of Stone."

I'm beside myself over the glorious cover by Pierre et Gilles, whose work I've long admired, and I'm very grateful to them for allowing us to use the image. Merci!

I'm grateful to Tanya Huff for agreeing to write the introduction, and for being such a delight to work with (as her editor) and for bringing me such delight with her work.

Leigh Grossman and Lesley McBain helped remove the worst of my grammatical errors and inconsistencies.

Some friends provided moral support, a sympathetic ear, and much brainstorming advice: Michael Bronski, Michael Denneny, Keith Kahla, Michael Lassell, Janni Lee Simner, Susan Wade, and Michelle Sagara West.

I am grateful to the editors who published many of these stories in earlier forms, for providing me with deadlines and advice and, especially, opportunities: Marion Zimmer Bradley, Michael Bronski, David Aaron Clark, Randy Dannenfelser, Austin Downey, Stefan Dziemianowicz, P. N. Elrod, Eric Garber, Richard Gilliam, Jewelle Gomez, Martin H. Greenberg, James Johnstone, Pam Keesey, Stan Leventhal, William J. Mann, John Patrick, Jennifer Roberson, Tristan Taormino, Cecilia Tan, Karen X. Tulchinsky, and Robert Weinberg.

And, of course, I am grateful to Cecilia Tan and Circlet Press for starting this necessary imprint to bring more queer science fiction

into the world. I am honored to be the launch title in the series, and hope this book is only the first of a long list of titles in the UltraViolet Library.

"An Oath of Bone and Velvet" first published, in a different version, in *Adventures of Sword & Sorcery* #2, Summer 1996.

"Barbarian Legacy" first published in *Sword & Sorceress XI*, edited by Marion Zimmer Bradley, DAW Books, 1994.

"Black Sounds" first published, in different form, in *The Time of the Vampires*, edited by P.N. Elrod and Martin H. Greenberg, DAW Books, 1996.

"Burning Bridges" first published under the byline David Laurents in *Honcho Overload*, June 1994; also published in *Wired Hard*, edited by Cecilia Tan, Circlet Press, 1994; in *S/X Magazine*, January 2, 1995; in *Barely Legal*, edited by John Patrick, STARBooks, 1995; and in *Flashpoint*, edited by Michael Bronski, Richard Kasak Books, 1996.

"Calvinism" first published in *Queer View Mirror*, edited by James Johnstone and Karen X. Tulchinsky, Arsenal Pulp Press, 1995; also published in *Ritual Sex*, edited by David Aaron Clark and Tristan Taormino, Masquerade Books, 1996.

"Coming Out of the Broom Closet" first published in *100 Wicked Little Witch Stories*, edited by Stefan Dziemanowicz, Robert Weinberg, and Martin H. Greenberg, Barnes & Noble Books, 1995.

"Crow Feathers" first published in *Sword & Sorceress XI*, edited by Marion Zimmer Bradley, DAW Books, 1996.

"The Drag Queen of Elfland" is original to this collection.

"Fag Hag" first published in *Return to Avalon*, edited by Jennifer Roberson, DAW Books, 1996.

"The Farrier and the Elves" first published in *Grave Passions*, edited by William J. Mann, Badboy Books, 1997.

"Femme-de-Siècle" first published in *Dark Angels*, edited by Pam Keesey, Cleis Press, 1995.

"Heart of Stone" first published in *Swords of the Rainbow*, edited by Eric Garber and Jewelle Gomez, Alyson Publications, 1996.

"Hemo Homo" is original to this collection.

"In Sheep's Clothing" first published in *Sword & Sorceress X*, edited by Marion Zimmer Bradley, DAW Books, 1993.

"Occasion a Need" is original to this collection.

"Old as a Rose in Bloom" first published in *Phantoms of the Night*, edited by Richard Gilliam and Martin H. Greenberg, DAW Books, 1996.

"Take Back the Night" is original to this collection.

Table of Contents

"Just keep thinking it's a happy ending and we'll be all right. . . ."

With the world tangled up in years of rapid social change, the fantasy genre is one of the best tools we have for contemplating "what if." Fantasy deals, almost exclusively, with exploring alternatives: alternative worlds, alternative histories, alternative belief systems, and, yes, alternative lifestyles.

Where else but fantasy could you explore the dynamics of a lesbian werewolf who runs an all-night feminist bookstore? Where else but here, in Lawrence Schimel's first solo collection, *The Drag Queen of Elfland*, would you have the chance to wander through so many worlds with so many people you already know? And a few you'd be better off not knowing.

This introduction won't go into the particulars of each individual story for two reasons. The first is that the line between enhancing anticipation and spoiling a reader's sense of individual discovery is one that I'd rather not cross. And the second is that these stories are so very personal for the characters involved that they should be equally as personal for the reader. My emotional reaction to a teenager, now living with her father and his lover, being visited by the spirit of her dead mother on prom night won't be yours and I'd never presume to tell you how to feel.

Oh, what the heck, maybe just once. The quote I began this introduction with is from the collection's title story, "The Drag

Queen of Elfland." It's a funny title and it starts off as a pretty funny story. It's hard not to chuckle at that aforementioned drag queen discovering he's the long lost heir, being whisked off to become Queen of the Elves, and finding that he's set new, shall we say flamboyant, styles at court. But under the camp, there's a man who "still thought and felt human." He's thrown into a new life, a life he didn't choose, with no chance to say goodbye to his old life. There's been a lot of that going around, hasn't there, and we all have to find what we can of a happy ending in spite of what we've lost. We have to or there's no point in going on.

Okay, stop worrying. I know; I've depressed you. It's okay, I've depressed me. But this is not a depressing collection. Nor does it come heavily laden with message and allegory. You can read each and every one of these seventeen stories purely for entertainment value, curled up on the couch with the cat and a decaf. But then, if you've got a moment more, you can take the time to really contemplate "what if?"

I don't know Lawrence that well. We've appeared in a number of anthologies together and he's edited me in two; I contributed a recipe to his recent AIDS benefit cookbook; we have an email connection when our servers allow it, but have only actually met twice. Due to the hour (late) and the length (short) of our first meeting, I retain only an impression of incredible energy. Fortunately, the second meeting lasted a significantly longer time than the first and we actually had the chance for conversation. Unfortunately, I still don't know him well enough to say that reading this collection will give you any deep insights to the author's character or beliefs. I will say that you can't miss discovering said author is a definite romantic with the eerie ability to get inside the skin of a number of very, very divergent

characters. And that he has an obvious fondness for puns. You may come to your own conclusions about the latter. . . .

And I will also say that in a field where one slender idea too often gets stretched to five or six or seven volumes, it's a joy to find a writer who can tell a story in a dozen pages.

Which is not to say that I wouldn't love to see what Lawrence could do with five or six or seven volumes.

—Tanya Huff
November 1996

As Tanya Huff says in her introduction, there's a fine line between "enhancing anticipation and spoiling a reader's sense of individual discovery" in discussing a story in introductions like this headnote. Nonetheless, I find that, personally, I always enjoy reading these brief introductions by the author or editor, contextualizing stories, giving some of the background into the story's creation or details of the author's life which dovetail with the story's content. Therefore, I chose to write them for this collection.

Some stories have more anecdotal interest than others. Some stories I am afraid to say too much about, beforehand. And, of course, the first bit is always the hardest, for me at least, to begin—a mix of stage fright and uncertainty. Which is one reason I always leave introductions until the end—they may come first in the finished book, but they're written last, at least in my books.

Yes, I'm procrastinating by talking about the subject, instead of just writing this introduction.

In many ways, this headnote for the first story—the first time I get to talk with y'all, the readers—serves more as an introduction to the entire collection which is named after it. Which is part of this indecision I'm facing now—what to write? But, that's how this book originated, really, sitting down and thinking: what should I write? What's new and interesting? What's missing from the genre? What deadlines do I have next?

I love playing with the reader's expectations, and for most of the writing I do, for anthologies grouped around specific themes, there's a lot you can know about the reader. When you pick up an anthology called Killer Dog Stories, *you know that each story will have a dog in it and the dog will kill someone. I find it very hard to write a generic story where the dog attacks and kills someone. I much prefer an indirect route, like having a puppy dig a hole which*

*trips his owner (or a burglar) who impales himself on a garden
object or breaks his neck in the fall: a "Killer Dog" that fits the
anthology's theme, but one the reader is not expecting. When asked
for a story about Excalibur, for instance, I wrote about a plastic
cocktail sword skewering a maraschino cherry; for a book of stories
about the Holy Grail, I wrote a* Jewish *grail story, since everything
else in the book, I was certain, would be traditional Christian
retellings of that myth.*

*The stories in this book are a mix of the lesbian and gay fantasy
and science fiction stories I've written over the past few years. Some
were written for traditional science fiction markets, and others
appeared in the gay press. There are different assumptions one can
make about each of these audiences: I have to spend more time
explaining about gay life in the first, and more about SF tropes I
otherwise take for granted in the latter. Since I straddle both the gay
press and the science fiction world, I like to think my stories work
equally well in both genres, and I hope this volume finds readers
among both gay and lesbian readers and openminded SF fans.*

*I also hope the book appeals to both men and women, since there
are stories about lesbians as well as stories about gay men in this
collection. I think it's important that we read across the gender
separatist boundaries that've sprung up in our homosocial
communities, which is one reason I write across gender boundaries
and include both sexes in this collection, and do projects like my
anthology* Switch Hitters: Lesbians Write Gay Male Erotica and
Gay Men Write Lesbian Erotica*.*

*Much of the fantasy I write draws heavily on mythology, and
refashionings of older archetypes into modern-day settings and
society. (Yes, I am at last moving toward the story at hand!) In part,
this is because these archetypes, particularly from fairy tales, are what*

resonate most strongly for me, and also because I enjoy the challenge of transposition, of taking something familiar and casting it in a new setting and light.

These archetypes, by and large, are extremely heterosexual. We're all taught to fall in love with Prince Charming, and those of us who're gay get to grapple with all sorts of additional baggage with that. So I like being able to write pieces which refashion old myths with a gay sensibility and plot.

"The Drag Queen of Elfland," for instance, draws on the same mythology that resulted in John Keats's poem "La Belle Dame Sans Merci." With, of course, my own peculiar spin added.

The Drag Queen of Elfland

As if eager for the sight of him naked, the fronds of Glenn's potted palm poked around the shower curtain to drink in the splashed droplets as he shaved his legs beneath the warm spray. They drank in the timbre of his voice, a smoke-husky contralto splashing against the tiles in a cascade of notes:

I asked an old man,
what is love . . .

Glenn paused suddenly, listening. He shook the water from his ears, and again listened for the strain of music he had just heard. He had thought, at first, that it was a melody running through his head, but he was certain now it had been coming from outside somewhere. He had never before heard the tune, and it ran counter to the song he'd just been singing; he'd never been able to summon a melody while singing or listening to another.

Glenn cut the water and strained to hear the music again. Silence. No . . . there it was. Like a trill of flutes, or perhaps voices in falsetto. He listened to them for a moment, before they dropped away once more. Glenn wondered who might be singing or playing. He gave a mental shrug and turned the water on again. He began to sing once more, running the razor upward along his shin toward the knee. He wanted not to need to hurry. He had always hated needing to get dressed in a hurry; his transformation was a process that shouldn't be rushed.

Glenn frowned at himself in the dressing room mirror and forced himself to yawn, trying to pop his ears. There'd been an almost-constant ringing in his ears since he sang his first set upstairs, a ringing that sounded just like that odd snatch of notes he'd heard at home when he was in the shower. Only it was no longer a melody, but a constant nagging whine. Glenn began to wonder if something were wrong with him. He hoped it wasn't an ear infection; he didn't feel any pain or dizziness, just heard flutes. He'd been perfectly fine until he began his first set. But by the end of the first song, the trill was there, distracting him—and now alarming him. He'd thought at first that he was again imagining that same song he'd earlier heard, or had thought he

heard. Only it didn't go away. Glenn stretched his jaws wide again and breathed through his nose. What if he—

There was a knock at the door, interrupting his train of thought.

"One moment," Glenn called out. It was always best to make them wait, even if you were ready for them. He looked himself over in the mirror and pinched his cheeks to give them more color.

The door opened anyway, ignoring his command.

Richard slipped in and crossed quickly to where Glenn sat. "You were wonderful," he whispered, nuzzling Glenn's ear, one hand massaging either shoulder.

"Why, thank you. How sweet of you to say so."

"No, it's you who's sweet." Richard began to nibble his way down Glenn's pale neck. He sucked the flesh where the muscle met the collarbone.

"Mmm. Don't. You'll leave a mark. I've got another set tonight."

"I know. That's why I came back. The Landis Project is due tomorrow and I'm afraid I'm going to have to run home now and get back to work on it." He lightly kissed Glenn's shoulder again, and looked up at him in the mirror. "But, save this for me for later?"

"Sure thing." Glenn gave his boyfriend a peck on the cheek, leaving a perfect lipstick mark.

"I'll never wash again!" Richard cried, cupping one hand over his cheek. Glenn swatted him on the ass with one elegantly-gloved hand. "It's no fair. *You* get to leave a mark." Richard crossed to the door. "Just you wait until later." He disappeared into the hallway before Glenn had the chance to respond.

Glenn stared at his reflection again, wondering what to do? If you can't beat 'em, he reflected glumly, join 'em. He began to hum, trying to match pitch with the noise in his ear.

Glenn shook his head vigorously, trying to dislodge the ringing in his ears. His wig began to slide off; he hadn't bothered to change before leaving the club, wanting only to go home and sleep and hope the sound was gone in the morning. But he'd promised Richard he'd come over—which was why he was sitting on the steps of a brownstone, trying to get a better grip of himself before continuing on toward Varick Street. Glenn didn't really feel like going to bed alone tonight, anyway. He was afraid he might need someone there, if something really were wrong with him. And he wanted someone to hold onto. Maybe sex would take his mind off those damned flutes. Or voices. Or whatever they were.

Glenn began to sing "I'm Nothing Without You," hoping to drown out their constant ringing by concentrating on a different melody. It didn't help. In fact, it made things worse. The ringing redoubled in volume. Glenn kept singing out of spite, refusing to let his body do this to him; his voice was his biggest comfort in life, not to mention how he earned a living these days. He would not let anything take that pleasure away from him

And then Glenn was holding onto the song because he saw shadows approaching quickly from behind him. Fear made his stomach clench, ice-cold.

Don't run, he told himself. It will only make things worse. If they thought he was a woman, they might want to rape him. If they knew he was a man, they were probably out fag-bashing. Or maybe they meant to rape him anyway, their irrational

homophobia leading them, or giving them the excuse in their own minds, to perform those very acts they abhorred. Resolutely, Glenn kept singing, but he was alert and on edge, adrenaline racing through him.

Suddenly, they were around him. Tall. Aryan blond.

"The Queen is dead," one said.

"You're her heir," another said.

There was nothing Glenn could do to stop them; they had him outnumbered, some sort of cult from the sound of it. He knew he should keep his mouth shut, but he couldn't resist quipping to himself, "I'm certainly having a bad heir day."

One of them grabbed him.

The ringing in his ears rose to a deafening pitch. Of all the times for his ear infection to act up! The world around him dissolved into vertigo; waves of black, then gray, then white.

The walls were pink. "I don't think we're in Kansas anymore," Glenn said aloud. He imagined he was in a hospital somewhere, one with a New Age sensibility regarding the effects of color on healing. He was about to disagree, since aesthetic indigestion must surely be bad for the endorphins, but he didn't feel any pain from the beating, so perhaps there was something to their color theory after all. Glenn did feel *something* in the air, something powerful, almost vibrating in the stillness, the hush.

Silence! That awful whine was gone! Glenn wanted to weep from joy, to kick up his heels and let loose with a song.

"I would wager they didn't tell you anything," a voice to his left said.

The man standing beside the bed was as tall and blond as the men who'd attacked him. Glenn wondered if he had been one of them. His demeanor revealed nothing.

Glenn tried to calm his galloping heart. He cleared his throat and said, "That's a bet you would win. Care to fill in the missing pieces? Like who are you?"

"I should begin," the man said, "by explaining who *you* are." Glenn's blood ran cold, even as his mind insisted that he already knew who he was. "You are a changeling, a faery child sent into the mortal world for safekeeping. You were substituted for a mortal child, who took your place here. Enemies of the Crown killed him many years ago. You are now returned to the realm of Faerie, which is your natural home."

Glenn's mind refused to wrap itself around this new information and believe it. Less strange was the news that he was in some supernatural realm than the thought that—if he were to believe this man—that his mother—his true mother, that is—had thrown him away. So this is the betrayal of suddenly learning that you are adopted, Glenn thought. It hurt. He could hardly stop himself from lashing out, verbally, sour acerbic wit. "People have been calling me a fairy all my life. I don't think this is what they had in mind."

The man smiled at him, and ignored Glenn's nervous repartee. "Come, I will show you about your quarters and the palace and explain what you will need to know about the Court."

On seeing his mother's closets, Glenn suddenly knew where his taste in clothes had come from. They were bursting with exotic dresses of elaborate materials and construction: silks and chiffons, silver gauzes and veils and lace and frills. They glittered,

they shone. Glenn didn't recognize half the fabrics, but he didn't care; he was too overwhelmed to care, although not too awestruck to immediately strip out of his now-rumpled dress and begin trying things on. Rhianon left off his lecturings and disappeared, though Glenn hardly noticed.

If only Richard could see me now! Glenn thought, examining himself in a full-length mirror. And why couldn't he? Glenn made a mental note to ask about bringing him here. If he was the Queen, he should be able to do as he pleased. And, anyway, a Queen needed a consort. But in the meantime, he ought to send Richard a message, just so he knew Glenn was all right. Richard was probably worrying himself sick that he had never showed up at the apartment. Glenn wondered idly how many time zones were between here and there.

Rhianon led him back to the Great Hall and, gratefully, Glenn collapsed into a seat—but not the large throne that dominated the room and was his birthright. His head spun with all the information Rhianon had just given him over the last three hours. The palace was enormous; just trying to keep track of where they were as Rhianon blithely ghosted along in his long mourning-gray robes, not to mention also trying to keep up with Rhianon while wearing a pair of heels that were too tight for him, took nearly all of Glenn's attention.

"So, do you have any questions?"

"Questions! I've got so many questions, they could fill an entire encyclopedia! But it's no use. You'll just have to explain it all again tomorrow. I just can't remember everything all at once like that."

"Very well." Rhianon turned to leave. When he was at the door, Glenn called out to him.

"Wait!"

Rhianon turned.

"There is one thing. Tell me about my mother. I want to know everything. What was she like?"

As Glenn walked through the palace the next morning, he could not help noticing that everyone, male and female, was dressed in fantastical drag outfits.

"Are they mocking me?" he asked Rhianon, as the pair walked towards breakfast.

"The fashion of the Realm follows the Crown. The Court will copy whatever you wear."

"Except you."

Rhianon did not answer.

"You despise me, don't you? You wish that there had been some other heir, some heterosexual heir who'd continue the line. Well, it's not my fault, dammit. I never asked for this. I never asked for any of this!"

Glenn stormed off, breakfast forgotten.

The gardens were tranquil, so long as he did not face the tall pink walls and towers of the palace. Glenn wandered among the odd plants and topiary, grateful to be outside of those walls. Something about their rosy pinkness made him uncomfortable and irritable, made him lash out like he had.

The sound of splashing water caught Glenn's attention, and he followed the noise to a fountain. Glenn sat on its rim and stared at his reflection in the basin, the fish beneath it. "I shouldn't

have done that," he said. Rhianon was his one source of help in this place, and if he burned that bridge he would be completely alone in this alien world. He must go apologize—but not right away; the thought galled him, not because he should have held his tongue—Glenn admitted readily to that—but because what he had said was true. Rhianon despised him, and having to apologize to a man who despised him hit him in the gut with a feeling of rebellion.

"Stop getting so involved in this," Glenn told himself. After all, this was all just a role he was playing, an amusement to pass the time until he went back to earth. Who wouldn't warm to being suddenly treated like royalty? It was the classic rags to riches story—or in his case, drag to riches. He only wished Richard were here with him.

Glenn stared down into the waters and imagined Richard's image. He began to sing, slowly, "The first time ever I saw your face." It felt wonderful to sing again. His ears began to ring a little, or perhaps it was the splashing of the fountain, but Glenn didn't mind he was enjoying the song so much.

And suddenly the world became shimmery, not just the water but everything—the white stones of the fountain, the trees, ground, everything—as if it were washing away.

Glenn jumped up and ran for the palace.

"Rhianon! I've been looking for you everywhere. What's going on? Is the Court under attack?"

"Attack? Explain to me what happened."

"I was outside, in the gardens, and all of a sudden everything went all shimmery, like the world was dissolving. It can't do that,

can it?" Glenn rapped his knuckles against a pink wall. "I mean, this is all real, even if this is fairyland."

"What, exactly, were you doing in the garden?"

"I was just going for a walk. I needed to clear my mind, and I just don't feel comfortable singing in here, because of the odd echoes and—"

"So you were singing?"

"Yes."

"Then, that's all it was," Rhianon explained, letting exasperation show in his perfectly modulated voice. "Sing it for me again."

Glenn looked dubious, but he took a deep breath and began to sing again. Almost immediately he heard that odd ringing in his ears—or flutes, or voices, or flutes and voices. And once again the world began to grow shimmery, and in his fear Glenn stopped singing.

"You sound just like her." Glenn's stomach felt queasy, shimmery like what happened when he sang. He knew Rhianon meant his mother. He could tell by the awed and reverent look on Rhianon's face, which quickly vanished when he saw that Glenn had noticed it.

"Is it the song? I'll never sing it again, I swear."

Rhianon sighed, exasperation and slight disdain creeping into his tone. "It's your voice."

"What?"

"The power of the crown is in your voice. Didn't you realize that yet?"

Glenn could not answer, words choking in his throat. He turned away from Rhianon and began to run.

Not his voice! Glenn thought. Anything but that! He had to be able to sing!

Glenn was terrified of his own voice, of the power it controlled. It was unnatural. He ran, blindly, away from the palace, across the Great Lawn into the forest. He didn't care where he went, he just had to get away. He had to get back to earth. But how?

"My voice," he realized, gasping the words aloud as he struggled through the trees and underbrush. "But how? There's no place like home there's no place like home there's no—"

The ringing in his ears began again and waves of vertigo hit him, shadows washing toward him: black, then gray, then white.

And then the world was normal again.

Someone was taking him a little more literally than he wanted. He was on the front steps of his parents' house in Hewlitt where he'd grown up. Of course, his parents had moved down to Florida years ago, and all the neighbors he'd known with them. Instead of the forests of Elfland, he was now stranded in suburbia, flat broke, in a blue chiffon evening gown.

"Out of the frying pan," Glenn said aloud. But he was overjoyed to be back on earth. Here, at least, he knew what the rules were, or at least that there were some. He began tromping across the front lawn toward the sidewalk. He'd call Richard collect and have him come pick him up. Although where Glenn would find a phone. . . . Suburbia is like that.

He'd probably have to beg for train fare money, he realized suddenly, demeaning as the thought was to consider. He thought of all the times he'd heard sob stories, of a guy who'd "just lost

his wallet and needed only four bucks to catch a train home. . . ."
He'd never believed any of them. And now he was in their shoes.

Not to mention his mother's four inch spikes, which left
walking home out of the question. Maybe he could hitch.

To console himself—and put him in the proper mood—Glenn
began to hum, "These Boots Were Made For Walking." He was
afraid to sing, but no odd flutes played harmony, so he began to
relax.

A man came bursting out the front door of a small yellow and
blue house across the street that used to belong to Ira and Doris
Blumberg when Glenn was a child. The man ran across the street
and threw himself at Glenn's feet. Glenn shied back, half-afraid
he was being attacked once again.

"You're beautiful!" the man cried. "I love you. I would do
anything for you."

Glenn almost wanted to laugh, but he was in no mood for
these hysterics right now. Why was his life suddenly one bizarre
crisis after another? His mom's dress must have a glamour
attached to it, that made him seem even more feminine than
usual, enough to convince this guido, unless he simply liked tall
women with butch faces. Glenn pulled off his wig, knowing he
might be getting himself in more trouble than it was worth—who
else was watching from their windows?—but he couldn't really
care right then. "Buzz off, I'm a man."

Glenn stared down at the red wig and smiled to himself. *All I
ask for is a little hairpiece and quiet. . . . Is that so much to ask
for in life?*

"It doesn't matter, I still love you."

What was this, Glenn wondered, a remake of the last scene of
Some Like It Hot?

"Look, I'm sorry, but you must go away now. I've got to get home."

He began walking away, but the guy followed him.

"Please, I'll take you anywhere you want to go. Just let me be with you."

Glenn was tempted by the offer of a ride, but who knew what this loon planned to do with him. Besides, it would tell him where Glenn lived, and he'd never hear the end of these protestations of passion.

Suddenly Glenn realized what was truly going on.

The Belle Dame Sans Merci! He was the Queen of Elfland, now! Why did these things only happen to him?

He looked down at the man, who was on his knees in the dirt as if proposing. He wasn't the kind of guy who made your jaw drop when you saw him across the bar, but he wasn't a troll either. Just some poor Joe who got stuck in the wrong place at the wrong time. Glenn wanted only to have Richard hold him and keep these weird happenings away from him.

Still, he couldn't help thinking about how far it was into the city.

"All right, you can give me a lift over to my boyfriend's house. But that's it."

The guy—Eric, Glenn learned, as they walked to his car—nearly exploded with joy. Glenn felt deeply sorry for him. He hoped Richard would be able to help him sort this whole mess out.

A strange man answered the door to Richard's apartment, and Glenn felt betrayal knife through his stomach, cold as ice. He'd followed one of the other tenants in the front door, so hadn't buzzed up, intending to surprise his lover. But Richard had

surprised him; after three years of a monogamous (or so Glenn thought) relationship, he didn't show up for one goddamned night, and Richard had already gone out and picked up a new trick. So much for that Landis project that was overdue! Glenn was beside himself with fury, he could barely speak, but at last he managed to stammer, "Where's Richard?"

"Sorry, lady, you've got the wrong apartment." The stranger began to close the door.

Glenn launched himself forward. "How dare you! I demand to see him right now, you man-stealing little bitch!"

The man pushed back. "Look, lady, I'm going to call the cops if you don't get out of here. I've lived here for four years, and there's no fucking Richard at this address." He slammed the door.

Glenn read the nameplate. L. GOODMAN. He felt himself go faint, the world swimming as he tried to make sense of it all. He struggled to support himself by leaning against the doorjamb, but failed. No Richard. Glenn sprawled across the hallway, uncaring, unaware. *Four years. . . .*

It had seemed like two days for Glenn, not years. But he remembered the stories now; time moved differently between the real world and Elfland. *Years. . . .*

Glenn went downstairs. Eric was still waiting for him, anxiously, in his blue Volvo. He happily drove Glenn all over the city, as Glenn tried to find one of his friends still at the same address. He didn't bother going back to his own apartment; he knew it would have been taken over as well, all his stuff thrown out, unless Richard had salvaged anything. Dresses, jewelry, his record collection. His Billie Holiday collection. Everything lost. Irreplaceable things.

Glenn suddenly knew why the elves had not pursued him. There was no longer anything for him here on earth. Nothing, except Richard. Glenn could stay, avoid returning to Faery for as long as he wanted to, but in the end he would wind up going back. No matter how out-of-place he seemed there now, it was the only place left for him.

But he was determined not to go back without first finding Richard, or what had happened to him.

"Glenn? Is that really you? My God, we thought you were dead? You look like you haven't aged a day. What happened to you?"

I should, Glenn wanted to say. I've aged one day since you last saw me, all those years ago.

But he couldn't speak. He sat down on the couch, letting Teddy make him tea and tell him everything that had happened:

Richard had blamed himself for not having stayed at the club. He was sure he could have prevented whatever happened to Glenn had he been there, and so never forgave himself. He wouldn't take another lover. Sure, sometimes he brought tricks home for a one-night stand, purely physical solace. But he never again allowed himself to love. He waited for Glenn, for some word one way or another; the knowledge that Glenn was conclusively dead. He waited years, and suddenly he took sick. He had nothing worth fighting for, and he did not linger long.

A radio blared from a nearby window. Cars zoomed past the sidewalk where they stood, weaving in and out of lanes to avoid the slower-moving traffic. Glenn wanted to step in front of one, to stop this ache he felt, this absence of Richard, forever dead

and gone, blaming himself and never knowing that Glenn was still alive and well.

Eric stared at him raptly, oblivious to all the life around him, and Glenn knew that he couldn't abandon him, to be forever tormented by lost love, as Glenn would be without Richard. He didn't want to be La Belle Dame. He might be heir to Elfland, might in fact be nearly immortal as they were, but he still thought and felt human: compassion, pity, responsibility, even though it had happened through no overt action of his own. Eric was like a doll in Glenn's hands, completely malleable and obedient to his every whim. According to the stories, he would be like that forever—or rather, the rest of his mortal life. There was nothing Glenn could do to change anything.

"We're going to step into a fairy tale, now," he told Eric. "You're going to have to say goodbye to the Earth forever. At least, Earth as you know it. You can come back and visit, but I don't know that you'll want to. It will be different. Everything you loved will be gone.

"But you will have me, for as long as you live. So just keep thinking it's a happy ending and we'll be all right."

Glenn held onto Eric, and began to sing.

I am a bookstore junkie. I take comfort simply from being in them—let alone from buying books in them, and seeing my own books offered for sale—and I definitely notice if I haven't visited one for more than two days. (Withdrawal!) I love working in them, because book retail is different than most retail—especially in the independent stores where I work. I love getting to recommend my favorite books to customers, and especially I love when they come back to ask for more advice, agreeing that the books I'd suggested were wonderful. And as a writer, I also find it invaluable to see how and why people buy books, what attracts them to a book and what turns them off, how much books actually are judged by their covers.

Bookstores, and the book business in general, are facing a terrible crisis right now. It is tremendously important to support the gay and lesbian and the feminist bookstores, independent stores that have served as community centers as much as retail businesses, that have nurtured and supported our literature and our voices for years before mainstream publishing recognized that queer books could be profitable and started involving themselves in the market. These are the stores that stock the full range of voices from our queer community, not just the assimilationist, apologetic books that won't offend straights that are the bulk of the queer titles the chain stores carry. And these are the stores that will continue to stock our voices, after the "fad" of gay books has passed.

But only if they continue to survive.

I am happy to have my books appear in chain stores, and I certainly hope this book is available from your local chain outlets. But I know that it's the independent feminist and queer stores who will keep this book in print, reordering it when it sells and recommending it to their customers.

"Take Back the Night" is set in a feminist bookstore that keeps my kind of hours. I'm a night owl, generally writing only between midnight and 4:00 A.M., then sleeping until noon the following morning. My freshman year of college, there was a twenty-four-hour bookstore in New Haven, and I loved going in to browse at the wee hours of the morning, as a break from writing a paper or for inspiration. Alas, it closed a few months into my second semester, and I've always wanted to find another bookstore that kept that schedule.

Take Back the Night

Some have said I'm crazy. Well, lots have said that about me, actually.

I run an all-night bookstore. An all-night feminist bookstore.

Take back the night, we'd demanded in all those demonstrations and marches. This is my way of doing just that, claiming the night as my own. I'm making a safe place for women to go to at night, a reason besides the bars for going out—and someplace to stop on the way home from them.

Not that I don't allow men in the store. Their money's just as good as anyone else's, so long as they're respectful, and I certainly need that money to stay open.

And, sure, I get a lot of riff-raff coming through, but I'm not the kind of woman to let that stop me. And anyway, the cops know to keep an eye on the place. The new guy especially, Albert, likes to come in, and every now and then I let him take a used mystery novel for free. His taste is for police procedurals; I never can figure out, if he's dealing with the stuff all day long, why he wants to read about it on his time off, but maybe he's looking for tips and pointers. I just hope he realizes reading is no substitute for experience, especially in his line of work.

One night in midsummer it was hot as hell and I had the doors open. Around 2:30 A.M.—late at night or early in the morning depending on your perspective. I was standing on the porch having a cigarette, since I don't allow smoking inside the store. Too much of a fire hazard, what with all those old dry books.

The moon was full and fat and sort of orange as it perched above the sports bar across the street, looking as if it were a basketball teetering on the rim of the hoop. I felt a powerful urge within me to jump up and slam dunk the moon right over into tomorrow, and right as I'm thinking about that metaphor a large dog climbed up the steps and walked into the store, just as casual as can be.

I looked around the street for the owner, but no one was in sight. I stubbed out my cig, and followed the dog inside. She was sitting in front of the cash register, as if waiting for me. I walked around the counter, wondering what to do. Call the cops? Was it the fire department who handles pets, or only the ones stuck in trees and stuff?

The pooch turned to face me, just sitting there, waiting. She wanted something from me, I was certain, but I had no idea what. A doggie treat? She seemed to expect me to recognize her.

I didn't know whose dog she was, and had never seen her around town. She wasn't wearing a collar. But something made me trust the beast.

"Come here, girl," I said, bending down. She eagerly came toward me, and licked my face and sniffed my crotch as I ruffled the scruff of her neck and stroked her back. "Didn't you read the sign on the door? NO DOGS ALLOWED."

I didn't really mind. I like dogs, a lot in fact. I just don't want them in my store. I was losing some customers by not allowing dogs—people out walking their dogs used to stop in and browse when I welcomed pets. But one night a man came in with a Doberman and the damned creature lifted his leg on two shelves full of hardcovers. Couple hundred dollars worth of damage, and I didn't even find out until after they'd left the store. Not even an apology. After that, the sign went up on the door. I figure I'm saving money in the long run, and who knows, maybe before I was losing customers who were afraid of dogs, who now felt welcome.

She barked twice, as if to get my attention, and then began to howl. I clapped my hands over my ears and stood up.

"Quiet there! You'll wake the dead with that racket!" I stared down at the beast. "I should change the sign to read: NO DOGS A-L-O-U-D, but you couldn't read it anyway."

She shook her head, as if to disagree.

"If you could read it, then why'd you come in?"

She disappeared into the back of the store. Had she come here to get a book to read? I wondered if I should follow her,

wondering what damage she might be doing to the stock back there, but just as I was about to set off after her she reappeared. She had a book in her jaws, which she dropped at my feet. I picked it up and wiped the slobber off on my jeans. *Women Who Run with the Wolves.*

I looked down at her, and her lips pulled back, revealing her large sharp teeth. She was grinning.

I felt like I was in an *X-Files* episode or some horror movie. She'd run with the wolves, and now was one. I wondered if she were one of my customers. I wanted to reach out and pat the top of her head, comfort her by saying "It's all right," but I didn't think it was appropriate.

Instead, I put the book down on the counter and looked out the still-open door at the dark night. "Kansas," I said, "I've a feeling this isn't Toto anymore."

The wolf and I sat on the front steps as I smoked another cig and tried to think of what to do. Or at least, what to do next.

At first I kept trying to brainstorm ways to cure her, since I'd fallen into the kinds of thinking that assumed that was why she had come to me. But as I looked at her, sitting next to me, I got to wondering more. What was wrong with her being a werewolf? Maybe she'd come to me because I knew her, or because she knew I'd understand. I had no idea how it had happened, whether she'd wanted it or not. She didn't seem agitated or anything, so why fix something that wasn't broken?

Although with canines, one did have them fixed as a preventative measure. . . .

I watched the smoke drift upward. There was just a tiny sliver of moon peeking over the edge of the building, like the slivers of

moon on my fingernails. I looked over at Wolf. Would she turn back into a woman as soon as that sliver disappeared? But no— just because we no longer saw the moon didn't mean it had set. Not yet.

I wondered about clothes. Would she have any when she changed?

I couldn't help wondering how long it had been since I'd seen a live naked woman. Not that I don't practice what I preach. It had just been a long time is all. I tried to remember exactly how long and gave up before I became depressed.

I tried to imagine what it would be like if it were me instead of her who'd wound up as a werewolf. And as I tried to figure out how I'd feel in her paws, I realized how much I'd changed.

I'd grown older.

I'd become such a goody two shoes. I no longer went to rallies, ACT UP meetings, no longer did any civil disobedience of any sort. I didn't have the time, struggling to keep the bookstore open and alive.

I'd turned into a solid, conservative businesswoman—a model citizen. I was a member of the chamber of commerce. I paid my taxes like a good little girl and didn't even complain all that much about how they were being spent. About the most radical thing I did anymore (besides run an all-night feminist bookstore) was sign petitions.

I felt sick.

I was disgusted with myself.

I'd betrayed all my earlier dreams.

Suddenly, I shoved my hand in her mouth. "Bite me," I said. What was I thinking? Was I even thinking? As the words flew from my mouth I realized I should've had her bite me someplace

else, that I'd be crippled with only one hand to use. Still, sometimes sacrifices must be made for the greater good and I didn't pull my hand back.

She waited for me to reconsider, then bit down.

I flinched, but it was only a pinch, and then a prick, like having your blood type tested at the doctor's office, the kind of prick you had to give yourself in biology lab.

And then the world dropped away in a flash of pain as her teeth broke skin.

I howled.

I have no idea what my body did. I think I thrashed about and convulsed. But my mind was numb to anything but pain. That pain was liberating, setting me free from my body. I looked down at myself, sitting on the porch of my bookstore with a wolf biting my hand, and I thought: well, why don't I *do* something.

That was when I snapped back into my body. She released my hand and I stared down at the neat puncture points her teeth had made. I was calm and detached about the blood that leaked from them; my mind kept repeating one phrase: why don't I *do* something? I'd been feeling this way for a while, I only now realized. Maybe this is why the werewolf was here, to wake me up from this stupor, reclaim me as a lesbian avenger. Not a *loup garou* but a lesbian garou. My mind began to race through imagined scenes, the power we would have.

I was already beginning to act like a werewolf: the bleeding was slowing as my new super-fast metabolism began to kick in. I figured I could get to liking this. I'd even get a humane fur coat out of it.

Of course, I had still to see how painful the Change would be.

"Watch the store," I told her, then went upstairs to get gauze and Neosporin.

When I got downstairs again, the wolf was gone.

In its place was a naked woman. "How do you feel?" she asked.

I looked her over: mid-30s, dark brown hair that hung to her shoulders, slightly overweight but seemingly unself-conscious about her body. Here she was, buck naked in a used bookstore, and she was able to hold a conversation. I liked that.

My hand throbbed. It felt swollen big as my thigh. "I'll live," was all I said.

And a part of my mind whispered that I would, that I would heal from any ordinary wound, heal from anything but silver.

She smiled and before I could help myself—I generally had more presence of mind, but perhaps I was too flustered at seeing a naked woman again, after so long, or maybe I was just rusty from lack of practice flirting—I blurted out, "Why me?"

She closed the coffee table book she'd been leafing through and put it down on the counter. "It was the wolf. Instinct. My feet just knew where to take me. I guess they knew you'd be able to handle this." She looked away from me, as if suddenly shy, and then added, "The wolf is not a solitary creature."

What was she asking of me? Or had I already decided, when I'd asked her to bite me? Was I now part of her pack?

She looked to me like I was the alpha female. So I took charge.

"Humans aren't either," I said, and reached for her.

I didn't bother to open the store the next day. For one thing, it had been so long since I'd had someone in bed with me, I didn't want to get out of it. And I'd just have to close up at sundown,

anyway, which would confuse people. What if I couldn't get rid of all my customers in time, I wondered, what if I turned into a snarling bitch right in front of them? Every store needs a gimmick these days, but that just didn't seem right for mine.

The Change began like a severe case of cramps, only it was all over my body at once, not localized to my belly. I wondered briefly if taking Midol or aspirin before the Change would help dull the sensations. I resolved to try it next time, just as my body convulsed and I lost all conscious thought to the pain.

When I uncurled my body from the floor and stretched my limbs, I knew something was different but I couldn't place my finger on what it was. Perhaps it was because I no longer had fingers per se. I yawned, my jaws gaping wide, and I knew suddenly how sharp my teeth had become. I'd felt them, the night before, when Laura bit down on my hand.

And Laura. She, too, would have changed. I could feel her near me, the heat of her body picked up somehow through my new wolf's senses.

I didn't bother to look for her, but nosed open the apartment door we'd left ajar and loped down the steps. I was oddly comfortable in this new body, as if I'd lived in it once before. Being a werewolf seemed to be like riding a bicycle, a skill you didn't forget. I jumped up and pushed open the outer door, which we'd blocked open with a rock, and ran out into the night.

This was nothing like riding a bicycle. This was like riding the wind.

I ran through the city's streets, hearing the click of my nails on pavement, and the echo of Laura's behind me as we raced.

I remembered how one night a friend and I had gotten dressed in male drag and gone out. We were packing dildos in our jeans,

and it gave us a glorious feeling of power. It made us feel cocky, in every sense of the word. We didn't know where else to go, so we went to a gay bar, and we watched the men cruising each other, and were ourselves sometimes cruised, sometimes cruising, wondering what we'd do if one of these big men took us up on our offers, how they would react when they got us home and found out our dicks weren't real. Would they want us to fuck them anyway? We never found out.

I remembered that heady sensation of power I'd felt that night, but compared to this, packing was just playing a wolf in cheap clothing.

This was power. I could feel the energy coiled in my limbs as my silvery pelt stretched and moved across my wolf muscles and sinew.

This was taking back the night.

I felt the familiar anger begin to burn in my belly, a hungering for justice and retribution. I wanted a fight, to test my newfound strength, to redress the balance. The night wasn't a safe place, only now it wasn't as safe for the people who made it unsafe.

I could be shot, I realized. I could be knifed.

Only silver can harm a werewolf, a voice inside my head reminded me. Although I didn't doubt that an ordinary bullet or knife would hurt like hell.

I prowled. My ears strained to pick up the sounds of any kind of disturbance. The city seemed eerily empty of that sort of activity.

How come nobody warns you that being a vigilante is boring as hell most of the time? Where was a rapist when you needed one? Were they all off having a pot luck somewhere?

Laura seemed to know my restlessness and pulled suddenly ahead, leading me off on a new path. Had she heard something I'd missed, more accustomed to understanding her lupine senses? Or did she just fear that I would attack some innocent passerby if I didn't find release for this building anger soon? We passed a dumpster with an enticing smell, but I didn't stop to investigate. I loped after her, anticipation building as we dashed through the alleyways behind buildings. I had no idea where we were, and wondered if I'd even be able to recognize this part of town if I were on the street looking at the fronts of these buildings.

I heard a scream, and all musings ceased as my body took over. I sprinted ahead of Laura and into the alley, my body working on instinct as it leapt. A man crumpled beneath me, and I could sense another body, the screamer, nearby, cowering against the wall. His body collapsed beneath my weight, my jaws gnashing as they closed upon cloth and flesh. Even as I bit I thought of Laura's pale thighs, like an atlas with blue vein roads leading towards the moist center of her sex.

And as my jaws locked on his shoulder and I shook my head back and forth, digging my teeth deeper into his flesh as he screamed, I knew, in the part of my brain that was still me and not fully animal: I must kill this man, or he, too, would become a werewolf, having been bitten. I must kill him or he would not merely run free, he would have this same power I now felt, use this force to attack others.

It was not hesitation when I released him, let him try to scramble away. I leapt on him again, and he twisted beneath me, rolling onto his back, his arms coming up to cover his face. My muzzle pushed through these weak defenses. My teeth sunk into his throat and tore and blood spurted into my mouth, warm and

delicious, and I growled deep in my throat with the sound of the release of pleasure, as if I were coming, or had my face buried in the wetness of a woman who was coming.

I tasted of the forbidden fruit, Adam's apple, and I had knowledge of good and evil. There could be no turning back now.

One thing you will notice, reading this collection, is that I am a hopeless romantic. I always think of this story as my unadulterated schmaltz story—which is not something I think is at all negative. It's a warm fuzzy kind of story, and I'm fond of it.

It's one of very few ghost stories I've written and was written for the anthology Phantoms of the Night, *edited by Richard Gilliam and Martin H. Greenberg.*

Old as a Rose in Bloom

My fingers trembled as they skimmed across the scroll of roses engraved along the box's sides. I had not touched it in years, and I could barely detect the shadow of my reflection beneath the large curving script on its tarnished silver lid. *MFG*. Marilyn Francine Gardiner. My mother.

She gave the box to me before she died. Inside, a pair of silver moons slept on a velvet bed beside a matching strand of stars. I had held my breath as I stared at them sparkling under the hospital lights from the box on my lap, like the glitter of sunlight on water.

"My mother gave me these on the day of my prom," she told me, her eyes misty with recollection. "I felt so proud as I wore them, old as a rose in bloom, and as beautiful." She took my hand in hers and made me look into her eyes. "I want you to wear them to your prom. Think of me when you put them on, so

I can be with you. In spirit, if not in person." She ran a hand through my hair as if she were combing it for me before the prom, and I nearly spilled the box and its moons and stars to the floor in a flood of silver as I turned to embrace her, crying.

I blinked back my tears again and set the box on the bureau, still not ready to open it.

Downstairs, I could hear dad and his boyfriend saying goodbye. Ed worked as a drag singer at a bar in town. At work everyone called him Natasha. Dad had been seeing him for eight months now, and Ed had basically moved in with us, but every night when Ed left for work they still spent five minutes hugging and whispering as they kissed each other goodbye. Dad was often asleep when Ed got back from work in the middle of the night, since he woke up at six to be in at the office on time. But I knew that sometimes he stayed up, worrying, or just waiting for Ed to come home.

For a moment I worried what my date would think if he showed up at the door and saw them through the window as he was about to ring the bell. It didn't matter, I realized, as I began putting on my makeup. Dad was happy for the first time in years, and I was happy for him. If I could only find the right lipstick to match my dress perhaps I could be happy for myself as well. I was the only freshman girl going to the prom and I wanted to be dazzling.

Dad began calling out to me as he climbed the stairs, "Erica? Erica?" He knocked hesitantly at my open doorway, suddenly shy or perhaps trying to give me some privacy. Whichever, my chest tightened in response to that tiny gesture and I felt in that

moment how much I loved him. He poked his head through the door and in a softer, excited voice declared, "He's here."

I turned to him and smiled, shyly.

"You look stunning," he said, coming towards me. He held me at arm's length for a moment, then kissed my cheek. I felt on the verge of tears, I was so happy. "How long should I keep him busy? Your mother kept me waiting for forty-five minutes. I sat wedged between her father and her older brother the entire time, too afraid to move a muscle, almost too afraid to breathe."

"I shouldn't be much longer," I said. "I just can't find the right lipstick."

"Twenty minutes, then," he said as he walked towards the door. He laughed, and I knew he was just teasing me. "I'll make sure he's occupied. Don't you dare come down sooner than ten, y'hear?"

"Thanks," I whispered, watching in the mirror as he went back downstairs. I was left staring at my reflection. I really was almost ready, except for the lipstick. I couldn't find the right shade; everything I had was too dark or too light or the wrong color completely. I looked at Mom's box again and realized I couldn't put it off any longer. I held it in my lap for a long moment; the metal felt cool even through my dress. I traced the large, curving letters, remembering her, missing her. My fingers wandered along the stems of roses around the sides. Finally, I opened the box. I'd promised her, and even more, I wanted her to be a part of this special moment with me.

The jewelry lay on its dark velvet bed, and sparkled as brightly as that first time I had seen them under the harsh hospital lights, still untarnished even after all these years. I lifted the twin moons and held them before me, trying to imagine Mom as a girl

wearing them. I put them on and stared at myself in the mirror. I look just like her, I thought, as I recalled the picture from her high school yearbook. I lifted the necklace—strands of tiny silver stars twisted gently, almost like a braid—and let the cool metal lie against my neck. I was amazed as I fastened the clasp how much I looked like Mom. She was so beautiful then, and now was again, in me.

I closed the box and placed it on the bureau. Something nagged me out of the corner of my eye, something I couldn't quite see. I looked at myself in the mirror again, and realized that my reflection had not moved at all! My heart began to pound within my chest. Could it really be her? I wondered. It was almost too much to hope for. I turned and stared at the young version of my mother who sat in the chair I had just vacated. No wonder I looked so much like her when I put her jewelry on; I had been seeing her!

I was scared, I must admit, even though it was my mother. And I was sad, as well. She opened her mouth to say something, but no sound came forth, and I could not read her lips. What had been so important to bring her back from the dead? I was elated to see her again, but felt guilty that I had disturbed her eternal rest, somehow. The ghost stood and spread her arms to hug me, but passed through me with a cold chill that froze my tears and made me catch my breath. Mom did not stop, however, but continued past me, and out the door into the hallway. I hurried after her, unwilling to lose sight of her when I didn't know if I would ever see her again. She had walked (or floated I realized later, since she glided from place to place) to the end of the hall and waited in front of Dad's bedroom. She was pointing

at the closed door, and when she saw me following her she melted through it.

I raced down the hall but stopped in front of Dad's closed door. As I put my hand on the knob, I couldn't help thinking about how he knocked at my open door earlier that evening, honoring my privacy. Nonetheless I turned the handle and entered his room. It was dark, but I was afraid to turn on the lights. He was still downstairs, entertaining my boyfriend. What if he came upstairs again to see what was taking me so long and saw the door to his room ajar?

I looked around the room in the light from the hallway, wondering what had disturbed Mom's rest. It looked like there was more of Ed's stuff in there than Dad's. Suddenly it hit me—was Ed the reason Mom had come back from the dead? Was she upset that Dad was sleeping with a man now that she was dead? I looked to Mom for confirmation, and sure enough she was pointing at Ed's stuff on the bed. I felt sorry for Dad—he really liked Ed, and I sort of liked him, too. Most importantly, Dad was happy again. He'd been so lost after Mom had died, and bitter, as if he felt she had abandoned him. But if Mom was so upset by his boyfriend that her ghost came back to tell me so, I guess I couldn't keep thinking things were good. I didn't know what she wanted me to do, however, and I looked at her again for another clue. She was still pointing at the bed.

She began to wail in frustration when I didn't understand. It was the first time she had made a sound, and I swear, it was loud enough to wake the dead. But maybe that was what she wanted.

Dad didn't hear a thing, or if he did, he never said anything about it. I moved closer to the bed, to see what she was so upset about, try and figure it out and stop her cries. Ed's drag stuff was

all over the bed still, wigs and dresses and makeup kits, all the stuff he had been using when he got ready for work a little while ago. Mom kept pointing at one cosmetics bag and, at last, I picked it up and held it out for her, wondering what she wanted me to do with it. She shook her head and kept pointing at it. Finally I realized she wanted me to open it. I felt nervous about going through my dad's boyfriend's stuff. I had no idea what was inside. Drugs? Money? Condoms? At least they used them. Dad had sat down with me and had a long talk about it, since he knew I might be concerned about him being at risk for AIDS and all that. Or did Mom mean them for me? Dad had given me some a year or two ago, but Mom wouldn't have known that. How embarrassing! My mother came back from the dead to explain the birds and the bees to me on my prom night!

I opened the bag. It was full of makeup: rouge, eyeliners, lipsticks. There was even a shade of lipstick that looked like it would match my dress. I didn't think Ed would mind if I borrowed it, so I pulled it out. I glanced up at Mom, wondering what it was she wanted to show me in there, but she merely smiled at me and faded away.

I wanted to laugh with relief, or cry. She hadn't been upset with Dad's boyfriend at all! I put Ed's bag back down on the bed, and walked to the mirror. The lipstick was the perfect shade; at last, I was ready. I still looked like Mom, I realized as I looked at myself in the mirror one last time before going downstairs to greet my date. "Old as a rose in bloom, and as beautiful," I whispered, and felt a warm glow of love envelop me.

"Fag Hag" was written for a special tribute anthology for Marion Zimmer Bradley. Marion bought my first story, back in 1989 when I was seventeen years old and still in high school, for her anthology Sword & Sorceress VII, *and I have always been grateful to and extremely fond of her ever since.*

Marion is fiercely loyal to "her own" and her writers fall under that category, like part of an extended family; she nurtures many new writers with her anthologies and magazines, and tends to many aspects of their careers and lives. When I took a semester off from Yale and moved to the West Coast (since I'd hitherto only visited states with Atlantic beaches) Marion gave me work on her magazine, which was vital to keeping a roof over my head and great experience as well.

On my most recent trip to the Bay Area, I visited Marion in Berkeley and had a fun chat about the lesbian porn novels she used to write in the fifties, under various pseudonyms. So, in many ways, our writing paths have crossed and come full circle: Marion moved from writing pseudonymous lesbian porn to being a well-regarded science fiction writer, whereas I began as an SF story writer and went on to write lesbian porn (such as in Switch Hitters).

Marion has always and admirably championed marginalized voices in her fiction. Almost singlehandedly she overturned the portrayals of women in high fantasy, with her retelling of the Arthurian mythos from the female points of view in The Mists of Avalon *and with her long-running series of* Sword & Sorceress *collections, in addition to her separatist Free Amazons in the various Darkover collections. But, while Marion posits a separatist community which has resonated for many readers, she continues to publish nonsexist writings by men, even stories about Free Amazons! (My sole Darkover story, for instance, was about the son of a Free*

Amazon, revisiting his mother, who'd been forced, by the Free Amazon's rules, to give him away when he turned five.) Often, the men she publishes are dubbed "token males" but Marion has no agendas or quotas to fill. She publishes the fiction which appeals to her, and to her readers, regardless of other concerns.

Marion has also championed same-sex relationships, in her Darkover books and in her mainstream novel The Catch Trap *especially, and it is in that spirit that I wrote "Fag Hag" for the anthology* Return to Avalon, *edited by Jennifer Roberson.*

Fag Hag

The witch's fork fell to the floor during dinner.

"Man coming," Avery told her.

The witch did not doubt her familiar. He had always been better than she at reading omens.

"I wonder what he wants," she said, wiping the fork against her skirt and knowing Avery would know. She stared at the cat, who would not open his yellow eyes to look at her. His tail swished back and forth over the edge of the table.

"Love potion. It fell facing East."

Instinctively, the witch looked to the window, where she could see the forest to the East of her cottage. She wondered if he would be coming from that direction, a traveler. Likely he would

be just another townsperson from the South. She almost asked Avery, but held her tongue. The cat swished his tail and did not open his eyes.

After dinner, the witch carefully arranged her cottage while waiting for the stranger to arrive. Presentation was vital. She placed objects on the bricks of the hearth to cast shadows across the room. The phantom shapes flickered as the flames licked the wood, as if the shadows were alive.

"He's here," Avery said, not lifting his head from the table, where he lay on his back.

The witch cast a nervous glance about the cottage to make sure everything was in place. She hated surprises. She would have liked an extra few minutes to prepare herself for the encounter, but hurried to the door. Avery's hearing was far superior to her own, but soon even she could discern the footsteps on the path to her door. They stopped. The stranger paused, no doubt to steel his courage, and just as he raised his arm and was about to knock the witch flung open the door and cried, "Come in, come in. I've been expecting you." She turned away and left him to follow her into her intentionally darkened abode. In her mind, she examined his image: she'd been expecting someone larger, she realized. No, not really larger, but older.

She turned to the boy who had come to her for help. "Now, for a love potion, you'll need to bring me some of her personal effects." He can't be more than fifteen summers, the witch thought. Younger than usually dared come to her for this sort of spell. "And they won't all be easy to come by, I warn you. I'll need a lock of her hair, which should be little problem to obtain. But I'll also need her blood, and not just any blood, but the blood from her menses. You'll have to find a way of getting

some. It doesn't matter if it's dried, if you can get ahold of her rags, so long as there's enough of it. There's just no making a love potion without it. And I'll need—" The witch stopped. The boy had not been looking at her, and he seemed . . . not exactly distraught, but something similar perhaps. She was used to people being fearful when they came to her, but this was different. "What *is* the matter?" she asked impatiently, for she had an image to maintain and she felt herself going soft around this boy for some reason. "You did come here for a love potion, did you not?" Could Avery have been wrong? she wondered. He was so good at reading omens, but there was a first time for everything.

"It's not for a girl," the boy said, quiet but firm.

The witch laughed. She tried so hard to intimidate her customers by knowing beforehand their desires. Their fear made them obedient and generous and kept her from worrying overmuch that she'd awaken one night to her cottage being burned by ignorant peasantfolk. But this time her assumptions had gotten the better of her.

"Can you still make me a potion?"

The boy was so earnest, the witch felt her heart going out to him. I'm definitely getting too old for this job, she thought to herself. Or perhaps she had simply been living alone for too many years.

"Yes, I can. It'll cost more, though, since I'll need to do extra research. I don't get much call for those, you understand."

The boy nodded. "I am willing to work for as long as is necessary to pay for it."

The witch regarded him again, and it almost took effort to not allow her surprise to show. Why did she keep underestimating

him? He had no money, which should have been apparent. He was obviously a farmboy with that sun-dyed skin, despite his regal cornsilk hair and bright blue eyes. He was still young, but already the muscles of his work showed on his light frame. She had bartered before, but usually with produce or livestock or objects, not labor. But she liked him, immediately, and she was impressed with his courage and determination. It had been many years since she'd had an apprentice to help about the place.

"I'll expect you tomorrow at sundown, then, and every evening until I've decided you've paid the debt."

The boy looked at the witch for a long moment, not frightened, but not cocky, either. Judging, perhaps. At last, he nodded, and turned.

The witch smiled after he had gone. She imagined the boy would grow less taciturn as he got to know her better. It would be nice, she thought, to have someone other than Avery to talk to.

"You're in a fine mood today," Avery complained.

The witch considered the cat's comment for a moment, and realized she was anxious about the boy's return. She bit back a retort to Avery and busied herself about the cottage, creating small messes for the boy to clean and repair.

"Why bother? There's work enough to be done as it is."

The witch ignored the cat, as the cat so often ignored her. She wanted the boy to start off on the right foot, without being lazy. She couldn't go about teaching him anything if he weren't willing to devote himself. And she also had an image to maintain; she didn't want him telling stories back in town about her personal life and effects.

"You understand," she told the boy, when he'd arrived at the cottage exactly at sunset, "that everything that goes on in this house is not to be spoken of—to anyone. Not to your parents, not to your friends. Not even," she said with a smile, "to your prospective paramour." He turned scarlet, even his neck flushing low into his tunic.

She did not want to breed a too easy familiarity too soon, and thus teased him mercilessly, and was domineering. She tested him, measuring his capacity to think and to learn—and to obey. In dealing with magic, it would at times be vital that he follow her orders unquestioningly, despite the rational seeming of the situation, lest a spell go awry and destroy them both. Faith was often half the battle. Especially in the case of a love potion.

It was more simple to create the desired aphrodisiac than she had let on, but the witch had been so taken aback by the request, or rather by the inaccuracy of her assumptions, that she continued in her elaborate pretense and delayed giving the boy the potion, which she'd already completed, assigning him various quests to obtain hard-to-find materials she needed for other projects, or those which would throw him into contact with his intended love, to begin establishing a connection between them.

The boy performed each request without complaint. Every evening, just before sundown, he arrived at the cottage, presaged the first week by a warning comment from Avery, but soon even the cat came to accept his presence as unquestioned and the boy set to work on one task or another before the witch had noticed his presence. At last, she relented, and gave him the vial, though he was to continue working for her to pay off his debt for it.

She asked him questions often, about life in the village, and especially about his boyfriend. His replies were mostly a terse yes

or no. Not out of fear of her, it seemed, but because he always spoke simply and directly, and chose not to speak at all when he did not have anything to say. His answers soon became more elaborate as the romance blossomed:

"He kissed me today."

"We held hands last night, when I left here, and sat talking beneath the elm at the crossroads and watched the stars."

But he never volunteered this information without first being asked. He seemed too shy, too bashful, even though the witch thought he felt comfortable around her and in the cottage. He was thoughtful and kind, and often took care of things she had not asked him to, simply because he had noticed they needed repair: bringing water from the river for her, mending the broken section of the fence that surrounded her cottage, transplanting the windowsill herbs.

The witch quite enjoyed his company, and the fact of having company about the cottage once again, but she stopped keeping him so late so that he would have time to spend with his love. That was, after all, the entire purpose behind his presence in her life, what he had come to her for. It seemed wrong, somehow, to deny it to him now, though she would be in her rights to exact such payment, should she so choose. The witch hardly regarded his presence about the cottage as payment any longer; he was, she realized with some alarm, a friend. She had not opened herself up, emotionally, to another person in so many years. She felt vulnerable.

The witch resolved to be merciless, to hold the boy at arm's length with taunts and work him as she would any apprentice. But when she tried she found that she could not do it, and instead listened eagerly to the boy's tale of last night's romancing.

The two boys were now inseparable when not working, and very much in love, it seemed. The witch was quite pleased with her handiwork. And the boy was so happy she couldn't bear to shatter that joy and innocence by suddenly holding him at arm's length, and for no reason at all. She was intensely jealous each time the boy spoke of his blossoming love affair, but she was also happy for the boy, and took consolation in that. Definitely too old for this job, the witch told herself, as all her suppressed maternal feelings bubbled to the surface.

There comes a time when all mothers must push their young out of the nest. "You're welcome to continue to come to the cottage," she told him. "I am in fact eager for you to continue to do so. But if you come, it must be of your own free will. You have now long fulfilled your obligation for the potion."

The boy looked thoughtful, and the witch felt her stomach churn. She knew, in her heart, that he would now leave her, and though she had meant to set him free, she had never really expected him to fly away from her.

The boy spoke slowly and carefully, and managed to look at her the entire time. "Thank you for the offer. However, we will now be moving to the West, where my love has an estate that his father bequeathed him. We plan to live there, where we hope to be free of the prejudices we have found in town, where people do not acknowledge our love."

The witch felt betrayed. After all that she had done for him, grooming him to be her apprentice and learn the secrets of magic she could unlock for him, and he would leave her now. She was glad that she had not had children of her own flesh and blood. She imagined it must be even more painful when it was time for them to leave.

The witch felt herself pulling back into a tight emotional knot from which she resolved never again to leave. One must open oneself to the risk of pain in order to feel happiness, she knew—and she had been happier these past few months since he began coming to the cottage, happier than she had felt in many years—but it was hard to not automatically lash out at the boy, for being, unwittingly, the cause of her pain. But when had this boy ever acted as she assumed he would? It as not his actions, but her assumptions which hurt her.

"Well, I'm glad to hear that my potion was so successful and that he is so very much in love with you."

The boy looked away and did not say anything.

"It would be appropriate to say thank you at this point."

"I. . . . Um. . . ."

"Whatever it is, you can tell me. You do know that, don't you?"

He gulped in a deep breath and said, "I never gave him the love potion. I dropped it before I had a chance to use it." He blushed, his neck and face turning red in his embarrassment.

A hundred thoughts and emotions crowded the witch's mind and heart. She ignored them, and tried to think rationally. "If you didn't use the potion, then why did you come work for me all this time?"

"You had performed your half of the bargain, and I felt it was only fair that I uphold my end of our arrangement, even though I did not, through my own fault, get to use what I had bought."

"And you never told me that he fell in love with you on his own!"

"You never asked. And I didn't know how to tell you without angering you, since you'd said it was so difficult to prepare the

potion and I'd wasted it. You'd always assumed he fell in love with me because of your potion, and it was easiest not to correct you." He looked at the floor for a moment, then back up at the witch. "But in a way, I'm glad," he said at last. "That I didn't use the potion, I mean. This way, he fell in love with me because of who I am. He wasn't coerced into it by a magic spell. I know that he truly loves me."

The witch was insane with jealousy, constantly comparing this boy's success to her own aborted love affairs; no matter what happened, everything fell into place for him.

No, not everything. They would face prejudice and hate and misunderstanding for the rest of their lives, similar prejudices to those she had experienced as a witch, being feared and misunderstood. None of her lovers had understood or trusted her, and she had never allowed herself to earn their trust. This pair seemed perfectly suited to each other, and she was glad that they had found each other to cling to, to face the rest of the world,

"Very well, then," she told the boy, letting him go because she knew she must. "You must follow your own destiny. I would ask one request of you, though: I would like to meet him, before you go." Meet this boy who is stealing you away from me, she left unsaid. She forced a smile, and the boy smiled back at her and nodded, and in that moment the witch knew that there had never been room in this boy's heart for anyone but his love, certainly not for an old witch.

This story was written for Marion Zimmer Bradley's anthology Sword & Sorceress XI. *My first fantasy story was bought for this series, so I always try and carve time in my spring schedule to write her something new.*

I grew up with chickens, in addition to many other pets. I had a small, brightly-colored bantam rooster, who raised many chicks with his harem of drab-colored hens. And my family, for almost eight years, had an enormous white leghorn rooster, named Alpo, who imperiously ruled the kitchen. Alpo would peck on the kitchen door when it was cold and he wanted to be let in to the warmth. He would roost atop the dog's crate, and ate kibbles out of their bowl, which is how he earned his moniker.

Chickens are not really creatures of high fantasy, the stuff of which legends are made, in the manner in which certain raptors seem to be. Nonetheless, I wanted to write a story about chickens—a quieter, gentler story, perhaps, than often appeared in the S&S series, but nonetheless a piece full of wonder and magic.

The Slavic legend of Baba Yaga, and especially of her magical house, has always fascinated me. So, drawing on elements of those tales, I wrote "Barbarian Legacy," which is a personal legacy, in many ways, for our departed leghorn.

Barbarian Legacy

Rows of sunflowers stood at attention in front of the inn, ever-vigilant sentinels. But their guard was not enough to stop winter

from settling over the land, not enough to stop time from running its course. As the cold wind blew down from the north, it blew travelers with it. They came with news of a harsh winter ahead, and of barbarians driven south by the snows. As the travelers left, Ilyana's workers went with them, scattering like leaves. They took everything they could carry, the cook nearly emptying her pantry completely. They left her just enough food for herself to last the winter. After they were gone, Ilyana battled with the birds and squirrels who attacked the sunflowers, stripping them down to mere stalks as they gorged themselves on the sun-ripened seeds. She needed those seeds to feed the chickens, her only companions now in the vast empty inn guarded by the skeletal stalks of the sunflowers. She'd hid the chickens during the hasty exodus, along with what clothes and money she had. What need had she to fear barbarians, when her own friends had come through before them?

She went early each day to the henhouse to feed the birds and, when luck smiled upon her, collect an egg or two. Ilyana woke them each morning, the seven small brown hens and the old rooster who glared at her for interrupting his rest until he saw the small handful of seeds. Long gone were the days when he rose before all others and crowed the morning awake.

One morning her henhouse was gone. The small building seemed normal when she first stepped out of the inn and made her way toward it along the packed dirt path, but as she drew near it stood up on two enormous chicken legs and began to walk away from her, taking one step back for each step closer that Ilyana took. At first, she ran toward it, afraid that the morning's eggs would break, the way the henhouse rocked back and forth, but it only ran from her all the faster. Ilyana stopped and the

henhouse did likewise. They considered each other for a long moment. When Ilyana did not try to approach again, it folded its legs under itself and settled down once more.

The henhouse looked strange sitting in the middle of the front courtyard, rather than behind the inn where it normally rested. Ilyana smiled to herself. Of course, it was also strange for the henhouse to have grown a pair of legs and to run around as it had been doing a moment ago. She wondered if the chickens were still inside it, if they were still alive. She listened carefully, hoping to hear the soft clucking of the hens, agitated at being rocked around, or the old rooster, grumpy at being aroused and not given his morning seed. But the henhouse was silent, almost seeming to bask, contented or self-satisfied, in the feeble warmth of the early winter sun.

Ilyana folded her legs under herself as the henhouse had done and sat down in the path, to contemplate what was going on, and what she should do. The small dark seeds in the pocket of her skirt spilled onto the hard, packed earth and she diverted herself with them for a moment, imagining the kernels were stars and making constellations out of their patterns. But soon she collected them all once more, safeguarding each kernel in the deepest pocket of her skirt.

While she had been playing with the seeds the henhouse had crept closer, as if wishing to be fed. Ilyana did not know what to do. She had enough seed to last the chickens through the winter, but not if she started feeding this enormous henhouse. However, she reflected, at the moment she did not have any chickens. They had all been in the henhouse which was now . . . transformed. Perhaps they were all dead. Or perhaps they were now the henhouse itself?

Ilyana suddenly had a ridiculous: what would happen if the henhouse were to lay an egg? Would it hatch a tiny henhouse, complete with little chicken legs? Maybe it would be a normal chicken egg, only the size of a small hog. She couldn't be sure of any of the scenarios, but laughed out loud at the thought.

The henhouse seemed to flinch at the sound, rising a few inches off the ground as it gathered its legs beneath it, ready to sprint to safety. But then it relaxed, as if realizing that Ilyana was not going to do anything, despite the loud noises. It leaned forward, still anticipating the seeds. Ilyana relented and tossed a handful of kernels to the ground in front of its door. She had no idea how it would eat them, since it didn't seem to have a mouth or beak, just chicken legs. It was, after all, a henhouse.

Ilyana watched in anticipation. After a moment, the door opened and the grumpy old rooster blinked in the light, gave half a crow and then hopped down to the path to begin pecking at the kernels. Delighted to see him again, Ilyana was standing before she had realized what she was doing. The henhouse jumped up onto its great big chicken legs and sprinted off a distance, leaving the oblivious old rooster pecking away at the sunflower seeds.

Ilyana sat down again, watching the rooster eat, and reflected that at least her flock was still alive inside the fugitive henhouse. If only she could figure out what had happened, and why, perhaps she could decide what to do. In a way, she almost didn't want to do anything. It was certainly interesting having a henhouse on chicken legs. Even with the chickens, Ilyana was very lonely, and the henhouse seemed more like company than the chickens did, if only because it was new. It was also a . . .

bigger companion, to say the least. It was more companionable because there was more of it.

Maybe it was barbarian magic, Ilyana thought, brought south with the cold winter winds. But who had cast it? And what exactly had been cast? Did the spell make chicken legs grow out of things? Would she find other objects suddenly growing chicken legs and running away from her when she approached them? Maybe it was a spell that gave houses the feet of whatever slept inside them?

Ilyana glanced over her shoulder at the inn to make sure it hadn't grown a pair of giant human legs and wasn't running off while she wasn't looking. When she saw it was still the same old inn—except for a shutter that must have blown off during the night and now lay on the ground beneath the window—she felt foolish for having worried. But after glancing back at the henhouse and realizing that it had crept forward again, she didn't feel all that foolish after all. This was magic.

Suddenly the henhouse opened its door again, like a great yawning maw. Ilyana tensed. What was it doing now? Would it attack, or was it releasing something new? Ilyana prayed it would be the rest of her flock, although she doubted it would be them.

It wasn't the chickens. Instead, a small barbarian child stood in the doorway, sleepy-eyed. Feathers and bits of hay clung to her clothes. The girl stared at Ilyana for a long time. She decided, finally, that Ilyana could be trusted, and jumped down to the ground. Ilyana wondered if there was anyone else still inside the henhouse. Had the child worked the magic that caused the henhouse to grow legs?

The child came toward Ilyana, mumbling something in her foreign tongue. Ilyana held her ground, hoping it wasn't a spell

being cast against her. This little girl was a barbarian child, after all. But Ilyana didn't really hold with the rumors of the barbarians' ruthlessness. Hadn't she stayed to brave both barbarians and winter, alone? And certainly so young a child. . . . She could more easily have attacked Ilyana with her magic last night while Ilyana slept.

The child held out her hand. Ilyana flinched, fearing the final component of a spell had just been cast. Then she laughed. "I'm getting as skittish as the henhouse," she said out loud.

In the child's hand was an egg.

They did not understand each other's language, but they would learn. It would be nice to have company during the long winter. "I only hope the inn doesn't grow chicken legs and run off," Ilyana said to herself as she cooked breakfast for the two of them.

"Black Sounds" has tremendous sentimental value for me, because it draws its details from a certain moment in my life, when I first lived abroad and studied flamenco dancing in the south of Spain. Unfortunately, I tore the cartilage in both my knees in a running accident, else I might be living in Granada right now and dancing still.

As in the story, it was through Lorca that I fell in love with things gitano. *My Spanish Lit professor's husband was a flamenco guitarist, and he played music while a woman from Granada (in New Haven because her husband was a Fulbright scholar) taught me to dance in exchange for English lessons. Eventually, I went to Spain and lived with her sister-in-law while I studied with a gypsy* matrona *and explored Andalucía. I was following Lorca's life in reverse, in many ways: he was born in Fuentevaqueros, just outside Granada, and ended his career with his book* Poet in New York; *I, a poet from New York, made a pilgrimage to his birthplace to study flamenco.*

My personal feelings about flamenco and duende *are included as part of the tale, so I won't delay in letting you get to them as part of the story itself.*

Black Sounds

It was blue like an endless sky streaked with magenta heat lightning. I crumpled the vest in my lap and sat on the edge of

the fountain in Plaza Bib-Rambla, wanting desperately to cry. I felt like such a fool; what the hell was I doing here?

A small dog yipped excitedly. I looked up and watched a handful of gypsy children chase a large plastic ball. Their limbs swung wildly as they tumbled over one another on the stone flags, racing and laughing, a Kodak moment of exuberant life.

I stared down at the brightly colored vest in my lap and wondered how much their carefree spirit was due to youth and how much to their gypsy upbringing. I'd always wanted to be bohemian. It's why I was here in Spain, an ocean away from everyone and everything I knew, pretending to learn to dance flamenco.

You're only young once, I'd told myself. This is the last time you'll be able to do this. If you don't try now, you'll soon be tied down with a job, a lover, permanently rooted in the humdrum existence of earning a living and daily mundanity.

In some part I was running away, unsure of what to do with my life now that I'd graduated. Down every path, it seemed, I wound up in some boring job I hated that I worked at for the next forty years . . . when all I wanted to do was learn to kick back and let my emotions run wild. I've always been a clam when it comes to expressing my feelings, thanks to being the only child in a totally dysfunctional family. This inward nature served its purpose to make me excel at school, get me into an Ivy League college, which I left sporting a solid GPA—but to what purpose, I wasn't sure. Was this what I really wanted out of life? Something—perhaps fear of the known, the inevitable future I saw for myself—helped me find the inner strength to buck my family's expectations of me, to throw caution to the wind and come here, a gamble, a risk. Nothing in life happens without

vulnerability. I knew that, intellectually, but even knowing it, understanding it, it was hard to live that way.

I'd fallen in love with the idea of the gypsy in a Spanish Lit class, reading Federico García Lorca. I knew, as I came to Spain, that I would not find them as I had in his writing, that he had changed them, made them larger than life. But I knew this with the English-speaking side of my brain, the critical side, which had studied and dissected the poetry, written essays about its symbolism and meanings. When I read the poems in Spanish they existed in a different world, a different level of meaning and understanding. In that world, los gitanos were still real. In that world, flamenco was a way of life.

By abandoning anything that was American, thrusting myself wholly and completely into the language until I thought in Spanish, dreamed Spanish, made Spanish the daily substance on which I lived, by so completely losing myself in and giving myself up to Spanish, I hoped to enter that world of Lorca's poetry.

I'd been here for three months. Tonight the Corpus Christi began, and I still couldn't dance. I knew all the proper steps—intellectually. I could demonstrate their sequence. But I didn't feel duende.

The word itself had confused me at first. Duende also means "faery," those wee folk of legend: imps and brownies and hobgoblins. But in flamenco it meant something much more complex, sort of the passion that is the energy of the creation itself. But like those fey creatures, who could only be seen out of the corners of your eyes, who, when you turned to stare directly at them, were gone, the duende of flamenco also had to sneak up on you when you least expected it. It was a feeling of zen

impossibility: the struggle to find duende is the struggle to stop searching for it, for some external muse to inspire you, to feel instead the act of expression and experience the feeling of it. Duende is the creation in process, which is why you can never catch duende. You can achieve duende, perhaps, but it passes through you.

It sounds so simple, boiled down like that to a phrase or two, but it continues to elude me, despite knowing the theory of it. And without duende, flamenco means nothing. You must feel the passion burning so fiercely you are consumed with it, and yet the dance is all control, the fire kept just under the surface, ready to explode, waiting to explode, wanting to explore. And you let it, sometimes—a controlled leak in the violent stamp of a foot, the sudden clap of a hand—loud, and powerful in the force of its desire. I've watched dancers achieve duende, and even as spectator it's one of the most exhilarating experiences I've ever felt. In those moments I knew why I had made this rash decision to come all this way on a gamble, with so little assurance of success of any sort.

But, it seems, I've failed after all. Tonight the feria began, a week of festival and dancing, and I still couldn't feel duende, couldn't break free from my shell to experience life. That was my whole problem; duende is the breaking of form, the bursting free of raw idea and emotion. It is the marrow of creation turned outside and exposed to the audience. It's a painful-sounding metaphor, but pain is exactly when duende is most powerful. It will not approach without the possibility for death, for then it's too safe. There's nothing for it to work with. Without the possibility of death one is already dead.

I threw the vest in the fountain and stood up. No matter how bright and flamboyantly I tried to dress, I was still dead, living an emotionless life.

Candela was gone to her computer class and the house was empty. I almost left again when I realized no one was home, but I didn't have anyplace better to go. I went into the kitchen to make myself something to eat and found a plate of rice with a fried egg on top of it waiting on the table. I smiled, even though it was the same thing I had eaten for the last three days, happy that I hadn't been forgotten. I popped it into the microwave and sat down at the table to wait for it to heat up. I munched on some wafers from the cookie tin while I was waiting and stared out the window. Candela had done the laundry that morning, so I would have clean clothes to wear to the feria, and it was now strung out on the line. They had a washing machine, but no dryer. I could recognize some of my own clothes mixed in among Marcelo's and her own, including some of my underwear! I was embarrassed to see it hanging above the courtyard for anyone to see. "Look," they probably pointed up at it and laughed, "the American's underwear!" I went out to the porch to try and pull the line in just enough to take my underwear down and hang it in the bathroom. But the moment I tugged on the string, one of Candela's blouses dropped down into the courtyard downstairs, followed by a skirt, and then a pair of my underwear that I'd been in the process of trying to hide. The microwave dinged, signaling that my lunch was ready, and I stared forlornly at where the clothes had fluttered down. I hoped they hadn't fallen into a puddle and gotten stained. I had to get them back upstairs before anyone noticed.

The courtyard belonged to the downstairs neighbors, who I knew were away at work. But they had a young woman who came and took care of the house and kids. Both doctors, they could afford it. I hurried down the stairs (being sure to take my keys— all I needed now was to get locked out of the apartment!) hoping the nanny would let me in and I could get the clothes before Candela came home from class. No such luck. As I was rounding the first landing I saw Candela at the bottom of the stairs. I pulled back, wondering if I could make it upstairs and pretend nothing had happened, but it was too late. Candela had seen me and she called a greeting up the stairs, asking where I was going. I tried to come up with an alibi, but all I could think of was the fact that I had only fifteen steps left . . . ten . . . five . . . to think of an excuse.

Candela joined me on the landing, her arms filled with her schoolbooks and paper bags with the days shopping, and I opened my mouth to begin justifying myself when I was saved by a voice from below, calling up to us. It was María, the girl who worked downstairs. She was holding my underwear, thrusting it up the steps towards us like the Statue of Liberty's torch or something, a beacon meant for the world to see. They had fallen into a puddle and gotten soiled, she explained as she climbed the steps towards us, Candela's blouse and Marcelo's pants tucked under her arm. My face was hot as a bonfire and I knew I must be blushing as I stared at the dark brown stains on my underwear, like I had gone to the bathroom in them. Suddenly I thought of a dozen clever excuses I could have told Candela if María hadn't heard us on the steps. So much for being saved.

As I followed Candela upstairs, I was afraid to wonder what would happen next. I thought of the vest I had bought this

morning, using half my spending money for the week, now floating like some alien blue fish in the fountain.

But the worst was yet to come. I had to go to the Corpus, much as I tried to talk myself out of it with superstition and these dark portents. I knew I wouldn't feel duende, would probably not even dance at all, since the few people I'd met so far, friends of Candela's, weren't going to the feria. But if I didn't go, I would always wonder if maybe I was wrong.

Why wasn't life simpler? All I wanted was to be spontaneous like the gypsies Lorca wrote of. A sudden flash of color, an image he threw at you, by itself, alone on the page like a bright red gardenia against a clean, lime-white wall. I could not even think that way. I sat with my journal and stared at this same city which Lorca had written about, but I could not see it the way he did. I tried to write poetry, in Spanish, in English, it made no difference. My mind refused to grab wildly at life, to latch onto the most prominent aspect of what I saw before me and exaggerate it, enlarge its proportion until it became truth.

Truth. Duende. I ached for life to be simpler, to be content with simpler goals.

The Corpus Christi was a weeklong festival where virtually everyone—except the family I was staying with and their friends— took time off from work and spent the week in celebration. A fairground had been built just outside the town, a small carnival with games of chance, roller coasters, and a Ferris wheel. But that was only one tiny part of the feria. Most of the area was taken up with casetas, little canvas houses where people drank vino and ate food and danced flamenco on wooden platforms that rose between the tables.

Casetas were like private parties; you had to know someone in order to be admitted. There were metal gates on most, and guards at the entrances. I knew from overheard gossip that there were some casetas run by the city of Granada, open to all, but I'd only passed one of those so far, the largest of the tents at the entrance to the fairgrounds, and while people were inside buying food and drinks, no one was dancing. I wanted flamenco; that was what I was here for, and I wandered about the fairgrounds looking between the canvas flaps for glimpses of people dancing. All of the casetas played music, some taped, some sung and performed by people inside, and I was itching to dance to it. But I was on the outside, uninvited. I didn't know anyone who could get me into one of the casetas where people were dancing, and even if I did, I didn't know anyone to dance with. And hearing music all around me, watching people enjoying themselves, I was not just itching to dance but feeling intensely lonely at the same time.

The only thing to do at the Corpus, it seemed, was eat, drink, and dance. Or feel lonely.

I wandered around the feria for another fifteen or so minutes, before heading out to where the buses brought people back to the city and going home, my new boots covered with dust but not danced in.

A young couple sat on a bench outside a caseta and I couldn't help feeling a pang of jealousy as I stared at them, cuddling and laughing together. Everyone had told me I would find a girlfriend at the feria, since I knew how to dance and so few men knew how these days, and the constant repetition had made me believe the thought was my own. I didn't want a girlfriend, of course, but the flamenco mindframe was one of compulsory heterosexuality; men could not dance with other men, only alone or with women.

The very language was heterosexual, with its gendered words, diving the world into male and female in corresponding parts. I did not fit in here, on so many levels.

I envied the pair before me—their freedom to love, to dance with each other, to live large and wildly—and I hated them. I was here to learn those things, to feel love overwhelming me, passion that consumed; I wanted to discover emotion, exuberant and uncontrollable. I was trying to embrace myself, and instead I was drowning in the my failures, my incompleteness.

I shook my head to put the young couple out of my mind and continue on towards the buses, but I couldn't. Without giving myself time to think I bought a soda from a vendor and hurried over to the couple, accidentally tripping over their legs and spilling it all over them, dousing their happy young passion in Coca Cola.

The boy stood up, angrily towering over me as he shouted something in Spanish I didn't understand. I turned and ran and lost myself in the crowd.

Why had I done that? I asked myself. They had done nothing to me. And I didn't even feel better having done it; pain and angst still sat heavy in my belly.

There was motion and noise all around me, but I felt I was safe. The boy would forget me and return to the girl sitting on the bench. I looked around me more attentively, wondering where to go to next, and realized that in my hurry to get away I had accidentally put myself in exactly the position I had wanted to be in—I was inside a caseta! I still didn't know anyone, and wanted desperately for someone to dance flamenco with, but for the moment it was thrilling simply to stand among the throngs of people listening to the loud music and watching the pairs of

girls and occasional couples dancing sevillanas in the center of the room.

Inside, the caseta was more elaborate than I had realized. There was a bar at the far end, and the wall in that part of the caseta was solid, not canvas. It was tiled like a decorated kitchen that might have been in any home in the city.

Everyone was dressed to dance: the women in elaborate gitana dresses, frilled and tasseled and ornate, and the men in somber gray suits, a bright swatch of color at their waists from their cummerbunds. I again felt conscious of how out of place I must look. I wished I had kept the bright blue vest. If I weren't more afraid of never again having this opportunity, I would've bolted for home and changed. But no one questioned my presence, and I stayed. I still felt isolated and alone, but I was determined to stick it out. I glanced about the room, half-defiantly, daring someone to come over and tell me to leave. My earlier almost-fight had gotten my adrenaline racing, and my blood was still pulsing fast.

A glamorous, dark-haired woman across the caseta noticed me watching her. An odd expression crept over her face, as if she half-recognized me. As she began walking toward me, I realized it was that she hadn't recognized me, and planned to throw me out. I looked elsewhere, at the couples dancing on the wooden platform, and kissed my last chance at ever climbing up there goodbye.

She was before me, looking even more striking than from across the room. Her lips were the same lush color as the red stripes snaking their way up and down the ruffled white fabric of her dress. White roses were twined through her black hair, pulled tightly into a bun, away from her face. I imagined it loose,

spilling over her smooth olive skin. I'd always wanted to hold her sort of beauty, the kind that drew men to her.

She opened her mouth, as if to speak, and I imagined the words she would use, telling me to get out of there. But she did not say anything, merely smiled, and took my arm. I drifted after her, unable to believe what was going on. We climbed onto the platform as one set ended and stood, staring into one another's eyes, as the music began anew. I did not think, not about dancing, or the music, or steps. I watched her, and to my surprise, I wanted her, and felt our mutual desire become movement. Later, I would realize what had happened, how she had made me forget to strive for duende, so preoccupied instead with desiring her, which allowed duende to well within me, all my frustration and isolation and all those years of repressed emotion exploding through my blood at once. But I was in control; I channeled this energy toward her in our dance, gestures of power and wanting and need.

I felt almost faint with the heady sensation of potency I felt. We danced, and I was sustained by the dance. If my mind were capable of rational thought, I would've remembered one of Lorca's lines of theory, that to feel duende should exhaust one, since passion is both generated and released. I was swollen with our passion, buoyed by it. I did not question its release. She stepped toward me, her lips full, and broke through the dance to kiss me. Our lips met, and a charge ran through my body, as she spun away and continued dancing as if she had never broken step. I did not know whether to expect another kiss as we both stepped toward one another again; I was in alien territory, feeling this overwhelming passion course through me. The fact that her gender did not match what I thought my desires should be did

not bother me; I cared about nothing, so long as I did not lose this sensation. We danced, duende coursing through me, changing, but always part of me; it was like that saying that you can never step twice into the same river, for the water that made up the river when you first stepped into it is now gone, replaced by new water, different water that makes up the same river. Even when you stand within it, duende is a different river.

The music was building toward its climax. We danced. She spun. She reached out for me, breaking the form, breaking the duende, kissing my lips, my neck. I felt her lips, warm against my flesh. She nipped at my skin, as if desperate for a taste of the duende rushing through my blood.

I must have fainted from the cessation of dancing, exhausted by the expenditure of passion and energy, by the passing of the duende through me and out of me when the music and our dance ended. I opened my eyes. Men I did not know were helping me sit up. Faces pressed about me, talking in a language I did not understand. I blinked and tried to stand, to push past them and find her again. I needed her. Where had she gone?

They held me as I fell back again. She was nowhere to be seen. I had one last memory of her, from just before I fell, of her staring into my eyes, her lips full and red like the stripes on her dress, and red roses woven through her hair, which hung in black cascades about her shoulders.

Someone pressed a handkerchief to my throat, and I reached up to touch it. My fingers felt slick. I pulled the handkerchief away and stared down at the dark red splotches, like roses startling against a clean lime-white wall in sunlight.

I wanted to cry out then, my frustration, because of what she had done. But of course I could not, would never be able to do

so—to shout with abandon, a wild and exuberant expression of emotion. For she had taken from me my capacity for duende, not just the passion of our dance together, but all the passion that was in my soul, my capacity for creation and expression.

Why me? I wondered briefly. But I knew why: foreigner, queer, I did not fit in here in so many ways. I did not fit in, and would not be missed.

They moved me to a seat at one of the tables, these strangers, when it was I who was the stranger within their midst. And slowly the world closed around me again, like flesh creeping over to heal a wound, and couples started to dance when the music started up again, but it was all just noise to me, black sounds and darkness.

This story is less fantastic than any of the others in the collection, in terms of its supernatural content, but I think it is unquestionably a fantasy, in all the senses of that word. And it really does have, in my mind at least, a magical realist quality.

Many of the details are drawn from my own undergraduate experience. Yale does offer a multidisciplinary art history course called "AIDS and Its Representations." I never did take the Mayan Hieroglyphs class, because I did so poorly in the professor's more-general Mesoamerican archeology class, which was a prerequisite for the Hieroglyphs seminar. (Even though I got such a low grade for the class, I did wind up with a good story from the material, "A Fire in the Heart," which can be found in the anthology Tales from the Great Turtle, *edited by Piers Anthony and Richard Gilliam.) And, living now in Manhattan, where it costs eight dollars to see a movie, I desperately miss the Med School's Film Society.*

When my editor, Cecilia Tan, first read this story, she remarked that there really ought to be a brand of condoms called "Lucky Charms." Any entrepreneurs out there?

Occasion A Need

Between classes I trudged through the snow to the post office. The city plows had created huge, nigh-impenetrable buttresses to the sidewalks, like the snow forts I had built as a child with my next door neighbor and best friend, Stevie. Some frosh were

making snow angels in front of Yale Station and I watched them for a moment, staring at the marks they left behind like large, alien hieroglyphs—or perhaps I thought that only because I had just gotten a C+ for my anthropology paper on Mayan Calendric Runic Inscriptions and hieroglyphs were still on my mind.

ACT UP had set up a table in front of the banks of mailboxes and some volunteers were giving out condoms. I'd only come out last semester, though I'd been furtively having sex for years; ACT UP still made me nervous. I guess I'm not used to confrontation, to being so militant, even though I know I ought to be. Especially now. They're fighting for me, and I'm afraid of them.

Jimmy stood up when he saw me and walked forward. "Happy Valentine's Day, Peter."

V-Day. I'd forgotten.

"I haven't slept with anyone in over four months," I said, refusing the proffered silver-foil packet. "Not since. . . . You know."

"I know. And it's a shame. You're cute, and I know tons of guys who'd like to sleep with you, even knowing you're seropositive. Get a grip, Peter, it doesn't mean your sex-life is over."

We'd had this argument before. "Yeah, well." I walked past him and down the row of boxes. I knew, intellectually, that sex could still exist for me, but I just couldn't get my mind to conceive of my actually doing it, not when sleeping with me could mean someone else's death.

My mailbox contained two pre-approved credit card offers and an overdue notice from the library for a book on Mayan hieroglyphs I'd checked out for my anthro paper and never read. Maybe I'd have gotten a better grade if I had. The book was

propping up the couch in the living room, where I'd been sleeping for the past two weeks because my roommate Robert had a new boyfriend.

"Just take it, Pete, you never know what will happen. Possession will occasion a need."

I took the silver square, if only to get Jimmy off my back.

"Atta boy. You can at least stick it into your journal, if you don't find any better uses for it."

There was a thought. Jimmy and I were both taking an art history course called AIDS and Its Representations. We were supposed to be keeping a stream-of-consciousness log about our thoughts on any reference to HIV or AIDS in the media or in our lives. I was the only one in class who was actually positive—at least, so far as we all knew.

I put the condom and the letter from the library into my backpack, pulled the hood up on my jacket, and braved the icy New Haven winds as I made my way across Old Campus to my English class.

I sat on the couch (AKA my bed this week) and tried to concentrate on my Rocks-for-Jocks problem set but all I could think about were Robert and his boyfriend fucking in the bedroom, getting their rocks off. Much wasn't left to my imagination; the dorm walls were so thin I could hear every caress, let alone Robert's screaming, "Yeah, Brad, fuck me hard!" every other minute.

I rummaged through my backpack, looking for something less demanding to better occupy my attention and came across my mail. I unfolded the library notice and the condom Jimmy had

given me in the post office fell into my lap. V-day. Shit. I'd forgotten for a happy while.

I stood up and pulled the hieroglyphs book from under the couch, which listed heavily. I tried various other books, and combinations of books, but nothing else fit quite right. I had to sleep there, after all, and couldn't be rocking back and forth all night, so I put the Mayans back under the couch and decided to just pay a late fee. Or rather, to have Robert and/or his boyfriend pay the late fee, since they were directly responsible for my not returning the book.

I picked up the condom again, wondering exactly how long it had been since I used one, remembering the one time I hadn't. I was tempted to walk into the bedroom and give it to Robert and Brad, but instead I pulled out my AIDS and Its Representations journal, paper-clipped the condom to a blank page and wrote a long entry about the post office, V-Day, and listening to Robert and Brad fucking. I was still writing when my train of thought was broken by Brad crying "I'm gonna come!" and I realized I had a hard-on from listening to them. I felt sick. I had to get out of there. I grabbed my coat and ran out into the snow as I put it on. Everything was white, the whole campus blanketed in white, pure snow. I walked aimlessly, kicking at the drifts, not wanting to go home, not really going anywhere either until I remembered there'd be a movie tonight at the Med School. The film society there showed movies every Thursday for two bucks. I hiked up the hill, only to discover tonight's feature was the ultra-romantic *A Room with a View*. V-Day. I'd forgotten. Again. I almost turned around and walked home, except I could still hear Robert and Brad's muffled grunting in my head and I bought myself a ticket. I swear, I was the only one there alone.

I needed to get away for the weekend, away from Robert and Brad and my homework and everything else, so I went to New York to visit my friend Michael at Columbia. While the train waited at the platform in New Haven (it was delayed by the snows) I stared out the window at a poster for *Angels in America*, and kept thinking I really ought to see it someday, considering how everyone raved about it, and also how it would now have very personal meaning for me. I dug my AIDS journal out of my knapsack and began to write about the presence that show has had in my life, even never having gone to see it.

A cute blond sat directly across from me. I smiled back at him, but nervously buried my head in my notebook again and hoped he wouldn't talk to me. Was he trying to pick me up? He kept watching me intently. He was cute, but I wasn't in any mood to talk right now.

He dug a notebook of his own out of his bags and we both sat there, furtively sneaking glances at each other and scribbling away. After we hit Stamford, when the train ran express to Penn Station, he interrupted me, and showed me his notebook. It was a sketchpad, and he'd drawn a picture of me. I was naked, with a hugely disproportionate erection. Totally unrealistic, but I was finding myself turned on by my own picture! And also by the fact that that was how he saw me.

I didn't know what to say to him. I looked him over, appraisingly, finally giving him serious consideration as a fellow sexual creature. I liked what I saw; I'd known that from the moment he'd sat down across from me, but was I willing to . . . ?

"The train doesn't make any more stops until New York," he said, standing up and walking towards the lavatory.

How long do you plan on staying celibate? I asked myself. All you have to do is be safe. He's cute. Go for it.

I could feel my stomach tying itself in knots as I stood up and put my journal in my bag, but not before taking the condom I'd paper-clipped to one of the pages and dropping it in my pocket as I followed him into the bathroom.

There was a swagger to my steps as I walked through Penn Station. I was certain everyone could tell I'd just had sex for the first time in months. I felt great!

So maybe Jimmy had been correct, I thought, as I took the subway up to 110th Street. Possession will occasion a need. And once I had awakened that need, it wasn't about to disappear. Suddenly, every man was a potential sexual partner. I hadn't felt this randy since I first discovered ejaculation!

I stopped at a drugstore before going to Michael's dorm, and bought myself a box of condoms. Trojans, although I would've preferred Ramses. However, they were the only kind the store had, and I didn't want to go hunting all over the city on account of a brand name! Jimmy's voice kept echoing through my mind like a mantra: possession will occasion a need will occasion a need a need a need.

I stopped at a café for coffee to warm up, and pulled out my journal to write about that boy on the train. I worried a little about what my professor would think, since the account was so explicit, but I didn't really care right then, I was still riding high. It was not talking about sex which made so many people have unsafe sex in the first place, so I spared no details. If nothing else, I thought, my prof should find some titillation when it came

time to grade my journal! I wondered if there was something similar I could do to help my Mayan Archeology grade. . . .

Since I'd written extensively about the condom I'd paper-clipped to one of the pages, expecting never to use it, never to be having sex again, I took one of the new condoms I'd bought and paper-clipped it into my journal. I was a new person, I felt, as I poured my psyche and libido onto the page, after all those months of being afraid to have sex, of remembering that one time I had sex without a condom. Sex was an integral part of life, even for someone HIV-positive, and I wasn't about to pretend any longer that it wasn't.

The waiter kept coming over to pour more coffee into my cup or more water into my glass or to ask if I wanted anything more. I knew what he wanted and wanted him to know I knew, so I left the page with the condom open on the table as I stared up at him, smiling. We kept flirting like this for another fifteen minutes, never saying a word other than the coffee-shop small talk, until at last he sat down at my table with me.

"I see you travel ready for everything," he said, staring directly at me with rich, coffee-black eyes and meaning, of course, the condom which lay between us.

"Indeed," I said, knowing I'd be writing about him in my journal soon.

Jimmy was drawing pictures of naked men in his notebook. I didn't know if he was feeling bored or horny; I felt both right then. Professor Sternberg was handing back our AIDS journals. I might've drawn pictures of naked men myself, except my palms were so sweaty as I wondered how he'd reacted to the level of sex in my journal that I couldn't hold a pen.

Suddenly, my journal was in front of me on the table. There was an A+ written across the front.

"I very much enjoyed your journal," Professor Sternberg said, before handing out the other notebooks.

I was in shock, but eventually I became simply smug. I flipped open my journal to see if he'd made any comments about any of the sections. I was especially curious to see what he'd said about the explicit sections. I'd practically filled the entire journal with sex episodes, at least after that condom Jimmy had so innocently given me on V-day.

I flipped back a few pages and stared at the mint-flavored condom that was paper-clipped into the journal. I'd left a Trojans.

I laughed out loud. He'd enjoyed my journal all right!

I turned to Jimmy and said, "Possession will occasion a need."

He smiled and asked, "What are you doing after class?"

When I heard that Pam Keesey was editing a sequel to her anthology Daughters of Darkness: Lesbian Vampire Stories, *I was overcome with the desire to write a story that was so inextricably both a lesbian story and a vampire story that she couldn't resist buying it. She didn't, and didn't even make me put it under a female pseudonym. In the end, I wasn't even the only token male in the volume—I'd encouraged my friend Thomas Roche to write for the collection as well, and one of the other writers began to undergo the process of gender correction between having written the story and its final publication, and had her byline changed to that of her male persona.*

As a result of this story being published in Dark Angels, *the publisher of Cleis Press approached me at a convention, saying that "Femme-de-Siècle" was the first time she'd read a story written by a man that read like it was written by a lesbian. I'd been editing a number of anthologies of gay male erotica at the time, and had worked with a number of women who wrote under male pseudonyms. But we didn't know of any men who were doing the reverse, writing lesbian erotica (or stories in general) and so I proposed the book which became* Switch Hitters: Lesbians Write Gay Male Erotica and Gay Men Write Lesbian Erotica, *which I co-edited with Carol Queen.*

I've never understood why so few gay men really understand lesbian butch/femme dynamics. I'd hoped that the women who wrote for Switch Hitters *would include butch/femme dynamics between men, but they all chose to tackle different arenas of gay male sexuality.*

I've often identified as a femme; for me, sexiness in women is always that femme fatale glamour and sultriness. Rita Hayworth in Gilda. The kind of woman I imagine myself to be, to have that

power to attract men. (Not, ironically enough, the kind of woman I find myself attracted to in real life, where it seems that certain butch women who look like cute, preppy, college-aged boys can hit all of the buttons I'm wired, as a gay man, to respond to. But that's another story.)

Femme-de-Siècle

She was cruising me something fierce. The way only a femme can do it: she ignored me. Not even a stray glance in my direction, and that was how I knew I had her. She was paying attention to my every move, watching me like a hawk from beneath those long dark lashes in order to pretend she didn't notice me.

I walked into a corner to think and automatically tugged on my baseball cap's brim, pressing it down against the back of my neck as I wondered what to do. I stopped myself. I knew she knew I was fidgeting, even though she was looking the other way. She was watching the bulldagger at the other end of the bar, but it was all just to make me jealous. My eyes kept coming back to her. She was gorgeous: Geena Davis come down to earth—and flirting with me! That pale skin, all that wavy hair, those lips: so full, so ripe, aching to be kissed. I was so hot I knew I must be leaving puddles on the wooden floor. But I didn't know how to approach her.

Fate gave me an opening. She reached into her purse and drew out a gold cigarette case. I grabbed the lighter in my jacket pocket and tried to think of what to say. "Can I offer you a light?" sounded too corny. "Give you a light?" "Let me light up your life . . ." I kept my mouth shut. I walked over to her and lit the end of her cigarette. She took a long drag from the thin, unfiltered cigarette and held it for almost a minute while she stared at me, unflinching, directly into my eyes until I felt like I was flying, swimming in the warm, dark essence of her soul. Then she blew a perfect smoke ring, which ghosted above my head like a halo.

Her voice was liquid music when she said, "Thank you."

That was the beginning. Mina came home with me that night, and every night that week. I was in heaven. She wasn't the kind of femme who liked to just lie there during sex; she was an equally active partner and, I swear, her sex drive was something else. She would strip me out of my clothes in no time flat the moment we walked through the door.

I never really learned much about her life away from me. I tried to ask gentle questions, without seeming like I was prying, but Mina never really opened up when she answered. It was only natural that I would be curious about her—hell, I was totally infatuated with her—and I tried to encourage her by talking about my life and past. I've always loved long, gossipy pillow talk sessions after sex, but she was as silent as a statue: beautiful, pale, and pretending to be asleep. I mean, there's trying to maintain an air of mystery, of allure, but there's also trying to hide something. Mina always came over to my place—I didn't even know where she lived beyond a vague and general section of town, and she had voice mail but never answered her phone—and it was always

sex right away and late into the night and straight to bed. I began to wonder if our relationship was actually so hot, or if she was having such desperate sex only to distract me from noticing something. Not that I minded the sex, mind you, but I began to pay closer attention to her. And that was when I realized, though it wasn't what I'd been expecting, that she didn't eat.

We'd been seeing each other every day for a week and we'd never had a meal together. She would nibble at stuff, but she didn't really eat anything. After sex, besides loving pillow talk, I get the munchies bad, especially when we'd been going at it for a long time. Mina would take the tiniest bites of what I tried to feed her, smaller than dainty—crumbs, really. And that was it.

I decided to test my theory out. When Mina came over the next evening I asked her, before she had the chance to tumble me into bed—or onto the couch, or in the hallway, or atop the kitchen table—if she wanted to split a turkey sandwich from the deli around the corner with me. I told her that I was famished and needed to have something right away.

"I just ate."

"Why didn't you wait for me?" I cried. I was hurt. But a sadness for her welled up deep inside of me, as well. Mina answered that she had held out for as long as she could and I didn't want her to waste away, did I? She was incredibly thin, it's true, but not all bones and skin; she was sexy and curvaceous. But I was also sure she was bulimic.

I didn't know how to approach her about it. I rubbed the back of my neck as I lay in bed, watching the gentle curve of her spine as she "slept," post-coital, before me, and wished I had left my baseball cap close enough that I could reach out and put it on without having to actually get up and hunt for it. Our life

together was rushing forward on a stream of inertia, and I was afraid that any change or confrontation would disrupt it completely. She would continue hurtling forward with her life as fast as ever, but in a different direction than me. I didn't want that to happen so I held my peace, biding my time and watching her even more closely when it came to food.

And then it wasn't just the food. Two nights in a row she got up while I was sleeping and left. Not a word of explanation, just put on her clothes and slipped out. I pretended not to notice, but I couldn't help feeling betrayed. We'd only been dating for three weeks and I was certain that already she was cheating on me! I didn't understand it; it wasn't as if the sex wasn't satisfying her, I didn't think. I was attentive to her, and always pushing her limits just a little to keep things fresh; I always asked her what she wanted, what turned her on.

"I'm always very moody when I get my period," she told me the next night. We fucked for hours. But still she got up in the middle of the night and slipped out of the house. I hadn't been able to sleep, anxiously worrying if, or when, she would get up and leave me. I, too, threw on clothes, and followed her. The night was quiet and clear: a harvest moon sitting fat on the rooftops, about to slip out of sight. She was singleminded in her journey, not bothering even to look about her as she made a beeline for Primrose, which was open until 3:30 A.M. on Saturdays. Even as I felt betrayal like a cold knife stabbing my stomach, I couldn't help thinking it was foolish for a woman out on her own at this time of night, even in this quiet neighborhood, to be so careless about her personal safety. It was inviting trouble.

I didn't have the heart to follow her into Primrose and confront her. I waited down the street, feeling like a gumshoe as I stood in the shadow of a doorway and waited. She didn't leave me waiting long, the bitch! Five minutes later, Mina came out trailing behind this insignificant wispy stick-figure of a woman. I'd been fantasizing about her and that bulldagger doing the hot and heavy, but this was all wrong. I didn't know what Mina saw in her tryst-trick, and that wasn't just jealousy talking! The woman looked unhealthy, pasty-white in the moonlight as she and my lover hurried arm-in-arm toward one of their apartments. I wondered if I would finally learn where my mysterious girlfriend lived as I followed them, every moment wanting to run up to them and stop them. I didn't know which of them I wanted to hurt more; I was ready to pummel them both. Was this the same woman Mina had been seeing these last few days, I wondered, as they slipped into a brownstone. They'd certainly picked each other up quickly enough, as if it had been prearranged.

The lights in a second floor window went on. Mad with jealousy, I raced down the street, looking for some way around to the back of the building. An alleyway led back toward the gardens that ran behind the buildings. There was a wire fence, and I didn't think twice before beginning to climb over it. I froze as two garbage cans shifted against one another, but no one seemed to notice the racket.

I moved from garden to garden more easily now, jumping fences when there weren't gates. Sure enough, I found the apartment where the two of them were reflected, *in flagrante*, shadows against the drawn windowshade. I'd recognize that hair anywhere, the silhouette of those breasts as her shirt was pulled

over her head. How could she do this to me? I watched Mina
lean forward and kiss another woman's lips, nuzzle greedily at
her chin, her neck. I turned away and climbed over a fence and
threw up and I don't know how I got home, but I woke up on
the kitchen floor, missing her and hating her and not knowing
what to do about anything.

I cried when she showed up the next evening like nothing had
happened. Me, bawling like a baby because she'd been unfaithful.

"I'm not cheating on you," she insisted.

Was anything she had told me true? Or had it all been lies and
secrets: the bulimia, those other lovers, what little she had told
me about her past. . . .

"I *saw* you!"

"And what did you see?"

*How pert your breasts were as you took your shirt off, how eagerly
you leaned into her embrace.* I couldn't speak.

"What you saw is . . . is that . . ."

I couldn't stand this pussyfooting around. "Just say it. You're
fucking another woman."

". . . that I am a vampire."

I burst out laughing. I couldn't help it, I'd been crying for so
long. It was just so preposterous.

She didn't find it funny. "It's true," she said. She smiled at me,
wide and toothy, and my blood froze. I blinked to clear the tears
from my eyes and stared at her fangs, like something out of a bad
movie. She closed her mouth. "I'm not cheating on you."

I didn't know what to say now, what to believe. Or how to feel
about her; was my girlfriend even human?

"Just assuming for the moment that I believe you, which I'm not sure I do, why three nights in a row? Just how much blood do you need to drink?"

"It's because of my period. I always need extra this time of the month."

There were more plausible alibis for her to have chosen, if she'd wanted to just put me off. I wanted to believe she wouldn't lie to me.

"It's not an easy thing to tell someone. It's like coming out all over again. Coming out of the coffin."

She came over and sat next to me. I was uncomfortable when she touched me, in part because I was so attracted to her as she lifted my head to look at her, then leaned forward to kiss me. These lips, I thought, have drunk blood. I thought I'd have been repulsed by the idea, but I was suddenly wet. Her kiss was gentle, but full of meaning.

"I think I like you a lot, too," she said, understanding, really understanding why I'd been crying. What was I going to do with her? Not just sexy, but caring, too; so what if she was a vampire—I'd dated girls who were into kinkier things than just drinking blood.

I wiped my face with my sleeve and smiled at her. "They must have a mondo hickey when they wake up the next morning. It must be hot."

We laughed, falling against each other so comfortably. She held me, wrapping her arms about my shoulders and letting me rest my head against her belly, just cradling me there while we spoke.

"It's not sex, but they dream."

That I could easily imagine. I had been lost in daydreams the moment I saw her: my hands running across her thighs; tasting the pink aureoles of her breasts; her hair spilling around my face as she slid her body along mine. . . .

We were pulling at each other's clothes, nothing but pure and mutual desire, making love as a communion of spirit and passion and a cleansing of misunderstanding.

She nibbled at my breasts, working her way towards my collarbone in tiny bites, and I bared my neck for her, trusting.

She stopped, pulling back from me.

"Why only femmes?" I asked her; not accusation, merely asking, finally opening the dialogue between us. "You don't like the idea of having sex with your food before you eat it? There are some girls who get into that, y'know? Have wild sex and then make a nice salad; cucumbers, carrots, zucchini. . . ."

She laughed, and bent forward to lick at my belly. "Femmes are more likely to be anemic."

This time it was me, holding her away, so I could look at her. "*What?*"

She ignored the way my voice had jumped an octave and tongued the crook of my elbow.

"Fewer calories. I'm on a diet."

I couldn't help myself; I nearly fell off the sofa I was laughing so hard.

"What's so funny? It takes work to keep this figure, you know." She slid her body against mine, to remind me how much I enjoyed her figure.

"I knew it all along. Only I had it backwards! I was positive you were anorexic because you never ate food. Now you tell me

you're a vampire, so that explains why you don't eat. But it turns out you're still anorexic!"

This time it was me who, after a long few minutes of silence, gently lifted her face to look at me. "It doesn't hurt them when you take blood, does it? I mean, maybe it hurts a little, but it won't kill them, right?"

She shook her head, hair spilling about her like a cloud of midnight.

"Next month, I want you to take blood from me when you need it. Promise me you will."

She stared at me, and I felt happily lost once again in the warm blackness of her soul. "I promise."

I rolled her over on the couch, looking down at her beautiful body, before leaning forward to devour her. "Good."

Holding her, after sex, she didn't pretend to be asleep right away. I whispered in her ear, "Y'know, I can't believe I'm now so eager for it to be that time of the month. It's funny how life is sometimes."

She didn't answer me, not in words, just kissed me, and held me tight.

As I said earlier, fairy tale themes crop up constantly in my work; they are the touchstones and archetypes which resonate most strongly for me. I especially enjoy transposing them, or other myths, into unconventional settings, drawing parallels.

In addition to chickens, I grew up with horses. Every member of the family had his or her own horse, although once I became a teen, I was the one to muck all the stables, even long after I stopped riding. (I always resented that fact that my sister rode, but didn't muck, whereas the reverse was true for me. Obviously, I still resent it enough to remember, and to write about it here. Ah, the bugaboos of youth that keep therapists employed!)

There is nothing supernatural in this story, although because it is a faery tale I include it in this collection, for are not faery tales intrinsically a part of fantasy (even those which do not contain faeries)? And it is grim, as faery stories were originally grim, before they became bowdlerized in the retellings.

It was published in Grave Passions, *edited by William J. Mann, an anthology of supernatural and horror stories by gay men.*

The Farrier and the Elves

The day after Billy had been out to The Little Red Farmhouse to shoe Irene Possilico's Morgan, a man named Walter Mayer called him. The voice reminded Billy of a newscaster, a voice that was never aquiver with emotion no matter how dire the report, but it

was hardly so precise; circuitous and dry and abstracted, Walter ran through an explanation of having asked the barn manager, Regina, for his phone number on the pretense of having Billy shoe the palomino gelding he boarded at The Little Red Farmhouse. Ever since he'd seen the man at the stable, Billy had been half-expecting the call, which Walter made during his lunch hour. Cars raced by on the other end of the line, a kind of static that made Walter seem ever so distant. Which Walter was: clandestine, illicit, and far away from the world he knew so well, or rather, the world that thought it knew Walter so well.

But Billy had known him from that first moment in the barn yesterday, a recognition that had nothing to do with desire, but with being desired. Walter—a man in his mid-to-late-forties, well-dressed in riding pants and jodhpurs, with dark, curly hair worn too long, in short, a man who was unquestionably bourgeois and, equally unquestionable, nondescript—had chosen Billy's arrival as the moment to clean his tack. He had sat in the aisle atop one of the feed bins the entire time Billy worked on Irene's mare, his arm moving rhythmically and suggestively up and down the bridle's leather straps, which dangled between his legs. Despite all the other scents of the barn—cedar shavings, the horses, Billy's own sweat as he stood close to the forge and pounded the metal into the proper shape, the smell of iron, of dirt and hay and late-summer—the peculiar bite of Murphy's Oil managed to pervade the air.

At the sound of tires crunching on the gravel driveway, Billy glanced away from the small black and white TV where Mr. Ed stomped a hoof three times to demonstrate a point (though, with the sound off, it could as easily have been in impatience) to the digital alarm clock. 9:55 P.M. Walter was early. Billy did not rise

from the bed as he waited for Walter to make his way around to the back of the barn.

Billy lived in a small, one room apartment converted from the hayloft of a no-longer-used barn. He'd given up his old apartment when he took sick; no way he could afford it when he wasn't working, not when all his money was going to medicines and drugs and he was too weak to go out and earn more. A blacksmith didn't have any sort of job security to fall back upon, sick days and the like. He made money only those days he worked. The hayloft was cheap, $175 a month. Billy made that much shoeing a horse and a half, when he was strong enough for the work. He didn't care that the place was small, or that at night he could hear the rats running through the floor beneath him. At least, he didn't care much. A shame there wasn't a cat or two, Billy sometimes thought, wondering why some strays hadn't taken up residence here. Who had ever heard of a barn without a cat? Even a barn that was no longer in use—at least, not to stable horses. He'd bought some dry cat food and set it out, hoping to attract some of the neighborhood felines to at least visit and patrol the place, but if they ever came, Billy never saw them, and he assumed it was the rats who ate the food he put out, or maybe raccoons, so he stopped buying it.

The bathroom, including the sink, was downstairs, in the old barn office. He'd rigged up a shower in one of the aisles, using the existing drainage system in the concrete floor. There was a curtain he could stretch across the aisle for privacy, but Billy never bothered with it; no one ever came into the barn these days and he enjoyed the safe thrill of almost-discovery, if someone should, for whatever reason, come in and find him, strutting naked through the old barn. Billy was as carefree and could-care-

less with his furnishings, keeping only a bed, the small TV, a table, and two chairs. To cook with, he had a coffeemaker, which looked as old as the barn and made coffee thick as tar, and a hotpot which he used to heat cans of soup if he were feeling too tired to go down to the twenty-four-hour diner by the train station.

The steps creaked. Walter knocked on the door. Billy waited, staring toward the television but not focusing on it, listening to the silence in the apartment, in the night outside, the sounds of Walter fidgeting on the porch. Did he feel guilty, standing out there? Billy wondered. Vulnerable? Or perhaps foolish, wondering if this were the right place, if anyone could live in such a place, and if that person was home? Billy stood and let Walter in, then sat on the bed again. Walter followed him, hesitant, fearful the place might fall in on him at any moment. Billy relished Walter's transparent disgust. It was like a bellows for the burning rage that sat in Billy's gut, but unlike Walter, Billy betrayed no emotion. He wondered if Walter were thinking of his wife and children, back in his fancy, expensive little suburban house surrounded by two acres of manicured lawn. What excuse had he given to go out at this time of night? Walter fancied himself so sly—the elaborate excuses, the subterfuges to keep his family, his secretary, his friends in the dark. He slept contentedly each night, his blond wife by his side, secure that he'd passed. It made Billy sick. He wanted something to jar Walter from this smugness. A car accident while taking his kids to piano practice, say. Walter driving and, of course, he survives. So he can feel guilty all the rest of his miserable life. Or perhaps a secret, deep inside him, festering, poisoning, dire.

Walter sat down in one of Billy's two chairs. The table was littered with scraps of metal—iron nails and horseshoes—and a now-yellowed issue of *Newsday*. Walter stared at Billy, hungrily, expectant, and smiled.

Billy ignored him, watching Mr. Ed's head bouncing as the horse silently laughed. Billy was distant, unreachable, and determined to be cruel. The need to lash out at someone was burning inside him. Why him? Why him and not someone like Walter, like all those hypocrites Billy worked for every day? The lock-jawed WASPs, the too-rich women with their bratty daughters who rode in Pony Club on horses like Mr. Ed. Billy reached across the bed and switched the TV off.

"You've got very nice biceps," Walter said, breaking the silence. "But I guess that's only to be expected in your business. One could say that you pumped iron all day long." He chuckled softly at his own joke.

Billy forced a smile, and beckoned for Walter to sit beside him. He hoped Walter would not make "stallion" jokes. They sat together on the bed, Walter suddenly shy in the face of inevitability. Billy took Walter's hand and placed it on the complimented bicep. Walter stared into his eyes, then leaned forward and kissed him. Billy kept his lips pressed together, but Walter seemed not to notice. He reached for Billy's body with both hands, still half-hesitant as they explored, and began kissing his way up and down Billy's neck.

Billy worked around horses all day but he did not ride. He knew how, had learned as a boy when he first decided he wanted to become a blacksmith, but he had never taken to being astride a horse, cantering along. But it hadn't taken him long to learn that men who rode horses were often fags. One trick had called them

"men who liked to put a beast between their legs." Billy thought Walter would like the joke (the double entendre seemed just his sort of humor) but he deliberately did not repeat it as Walter took off his clothes and lay on his back. Billy reached under the bed for the tube of K-Y jelly. His fingers brushed against a condom package, one of those free Lifestyles given out at bars, but he ignored it. Walter didn't say anything. Billy greased his cock and Walter eagerly lifted his legs into the air. You'd think a doctor, even an eye-doctor fercrissake, should know better, Billy thought. He felt a rush of power, a heady sensation of superiority as he pushed forcefully past the tight ring of Walter's asshole.

"Oh, yeah," Walter said, squirming on the bed, "Ride me, baby, ride me."

It was as bad as stallion jokes. Billy fucked Walter mercilessly. He let his rage overtake him and exhaust itself in this one act. Everything and anything that had ever pissed him off, from locking himself out of his car to being too sick to get out of bed and stumble downstairs to the bathroom, was suddenly being taken out on Walter's ass. Billy's out-of-control rage excited him and it was not long before he came, inside of Walter, his body shuddering, then still. He started to pull out but Walter begged him not to, then jerked himself off. In a moment, Walter's semen was spurting across his belly, and at last Billy pulled out of him and turned away. He picked a handtowel off the floor and wiped his penis, then walked around to the other side of the bed. He lay down next to Walter, but not touching, a gulf separating them in the few inches of space between their bodies.

As if suddenly self-conscious, Walter leapt up from the bed and put on his boxers. His cum clung to the hairs on his chest. "I'd have thought you'd wear jockey shorts," Billy said, tartly.

Walter smiled at him. "Yeah, you'd think so."

"Business has been lousy," Billy said, not rising from the bed. He'd lost all his customers when he wasn't working. You couldn't just take six months off and expect them to wait for you. Horses needed to be shod, and if you weren't around to do it, or weren't strong enough to do it, they'd find someone else.

Billy stared up at the wooden ceiling, thinking that if this were a movie he would be smoking a cigarette right now. Of course, it was never safe to smoke in a barn. They were all wood, and if one caught fire, there was no way for the horses to free themselves. But Billy knew he would look hot just then, naked and smoking in the post-coital silence.

"I'm sorry to hear that." Walter put on his socks, before stepping into his pants. "I'll talk to my friends and see who needs shoeing." He looked down at Billy, sprawled naked atop the sheets. Billy stared back at him, direct, defiant.

Walter reached into his pockets and pulled out his wallet. He placed a few bills on the table, anchoring them with a handful of nails.

"Thanks." Billy smiled up at Walter, but did not rise from the bed. He was sure it was a few hundred dollars. Walter was an eye doctor with a practice in Sea Cliff. He paid nine times Billy's rent each month just to board his horse; The Little Red Farmhouse was the most expensive stables on Long Island, a large and posh establishment off Rte. 107 (or Cedar Swamp Road as it was called in that section of Brookville).

"Um, I've got to go now."

Billy nodded. Walter let himself out.

Only when he heard the crunch of tires on gravel again did Billy stand and collect the money from the table. He folded the

bills and tucked them beneath his mattress. Unlike the princess and the pea, Billy slept more soundly because of the small lump beneath him, and dreamt all night long of winning the lottery, or the races on a five-hundred-to-one bet.

Walter called the next day, again during his lunch. "I think I found some work for you. I told my friend Roger Osgood about you. He races some horses at Belmont. He's going to be there all afternoon, and said if you come by he'll introduce you around, see who might be able to use you."

"Thanks, I'll head over there right now."

"Wait!" Billy listened to the long silence. "Can I come over tonight?"

Roger was another closeted faggot, although he didn't pass as well as Walter did. He was older than Walter, mid-fifties, sallow-faced and vaguely-androgynous looking. Wispy. A tired old queen hard up for a bone. Billy wondered what, exactly, Walter had told Roger about him, and what kind of work would be involved. Roger was the kind of man Billy would let buy him drinks all night long at some dive bar but still say no to when the time came to go home. A man just begging to be used. At first glance you've got him pegged: that dry, hungry look in his eyes; that belly, plump like a moneybag; a stuffed shirt.

Billy played Roger for all he was worth. He smiled, he flexed. Billy knew he was still good looking. He hadn't lost too much weight yet, still had almost all of his muscle bulk. Roger ate it up like candy.

At least, Billy thought, I'll never wind up this sad, haunting some smoke-filled piano bar every night and trying to buy me a boy.

It was no surprise that Roger gave him work shoeing his favorite horse, Neon Rainbow. He was besotted. He'd have hired Billy if only to have him around to look at.

Billy treated himself to a night out, what with all the money he was making from fucking Walter and from Walter's fucking friends at the track. He came home from the Silver Lining just before midnight, utterly spent. He no longer had the stamina for staying out all night. He'd danced and drunk and gone into the backroom twice with a Caribbean-looking boy who couldn't have been more than twenty-three. They'd done nothing more than jerk each other off, but it had felt so nice to touch his young, solid body, to run his hands up between those round buttocks, to feel the boy's long cock pressed against his thigh . . .

Someone grabbed Billy, strong fingers digging into his flesh from behind him. Billy was about to fight back, but froze. Cold metal pressed against his throat. "Sit down," a voice commanded. Billy tried to glance down at the hand that held his arm without moving his head. A tiny hand, like a child's, but stronger than most adults. And that voice: low and worn from too much boozing and smoking. This was no youth. What did this man want from him, want badly enough to break into his apartment? Not that Billy made it very hard since there wasn't anything worth stealing up here. And Billy didn't have anything worth extorting, either. Had this man made a mistake? Was he simply crazy? Itchy to knife someone? Billy longed to turn around and look at his captor, but the knife pushed against his skin. Billy

swallowed, involuntarily, the knife bouncing against his throat from this action, and sat on the edge of the bed. He waited.

"I heard you weren't doing so well," the man behind him said. Billy tried to imagine his assailant, but couldn't conjure any image for that voice. It sounded like the voice a parent might use to scare a child in a bed-time story about the bogeyman. Billy wanted not to listen, to hide under the covers, but the voice continued, "I heard that you needed some money. So I thought I'd come on over and help you find the pot 'o gold at the end of the rainbow. The Neon Rainbow.

"I'm going to help you make some shoes. These are special shoes. Shoes that'll make a horse throw the race without anyone knowing how or why. So it all seems like an accident.

"I want you to put them on Neon Rainbow tomorrow.

"And to help you out in your time of need, I'll give you twenty percent of the take."

Billy tried to think through what was going on, but it was as if all his mental gears were stuck and he were running in place. It was completely illegal to do what this man was asking him to do, but what choice did Billy have? The man pressed the knife tighter against Billy's neck, demanding an answer.

"Fifty," Billy said, at last.

The man laughed, a wheezing sound like the engine of an old car refusing to start, and Billy knew it had been the right answer, even though the knife stayed pressed against his throat. "You'll do it for twenty and be happy you're getting even that."

And Billy would be happy with that, he thought, calculating how much even twenty might be.

The man explained what he wanted for the shoes. Billy started to nod, then remembered the knife. "I'll do it," he said, instead.

His voice was dry and Billy hated himself for letting it crack. Never show fear.

"Good," the voice said, "I thought you would see it my way." The man pressed the knife deeper against Billy's throat so it drew a thin red line, then pulled it away.

The man wiped the knife clean against Billy's sheets, then put it away. Billy did not move. The man walked toward the door and Billy at last got a look at him. He was tiny and slim, and looked too old, somehow, wizened like a dried-apple doll. Like a gnome or an elf from a children's book. But this was no children's story. Billy could feel the marks on his arms and shoulders where the man's cruel fingers had dug into him, the blood trickling down his neck.

A jockey, Billy suddenly realized, as the man opened the door and everything fell into place. Billy tried to recall if he'd seen him at Belmont over the past few weeks. The man then turned toward Billy again and tossed something onto the table. It was a wad of bills. "Get a real bank. You're going to need one soon." The door closed.

Billy knew he'd have remembered that face if he'd seen it before. He'd probably have nightmares from it tonight.

Billy stared at the stripe of blood on the sheet. He could still feel the blade pressed against his throat. It had given him a raging hard on, and Billy jerked himself off again before putting the money back under his mattress and falling heavily and dreamlessly asleep.

Like a horse who spooks at linen drying on a clothesline and blowing in the wind, Billy now shied at bright, silvery clothing when he worked at the track. He couldn't help fearing each

slender and brightly-clothed jockey who crossed his path, nor staring intently into their faces. I'm looking for a man who looks like an elf, Billy thought to himself. But didn't they all, tiny men in that outlandish clothing and those pointy shoes?

The shoes were simpler to make than Billy imagined and that scared him. Something was bound to go wrong.

Walter called.

"Not tonight."

"Tomorrow?"

"No, not tomorrow, either."

"Thursday?"

"Look, I'm busy all week, all right?"

Billy was suddenly more nervous. Don't do anything rash, he warned himself, don't do anything out of the ordinary. Walter will call Roger. Roger knows I shoed Rainbow Neon.

"Be here at 9:15." Billy hung up.

Rainbow Neon ran. And won.

Billy ignored the knot of anxiety in his stomach and smiled and flexed for Roger.

Rainbow Neon ran again and again won.

Billy fucked Walter violently, desperately. He was all nerves, raw nerves. Try to stay cool, he told himself, cool, and distant. Have to maintain appearances.

Neon ran a third time and broke his leg. They shot him on the track. An accident. A pity. That was it.

Billy couldn't eat; he started losing weight. This is all psychosomatic, he told himself. They have no idea. Roger still lusted after him, still let Billy shoe his other horses.

Have to maintain appearances.

Billy fucked Walter even more violently than before, but it brought no release or comfort. He left marks which Walter's wife surely must notice, surely must ask him about. But Walter did not complain. Walter begged for it.

The races went on. One night there was a knife at Billy's throat again and twelve thousand dollars under his mattress.

"This isn't twenty percent," Billy complained.

"I'm holding the rest in reserve for good behavior."

"No way. You're out of your mind. Look, if every horse I shoe suddenly breaks a leg, it won't take a genius to put two and two together."

"Don't worry about it; I'll take care of things. We'll find you some more horses at the track. It'll only be one out of the batch." The jockey grinned. "At least, for now."

Billy forced himself to eat. He drank protein shakes three times a day. He didn't want to lose any more weight. Had to maintain appearances.

He had more work than he knew what to do with. He went to good doctors and got the best drugs. He could afford it now.

He was giving himself an ulcer.

Dead horses ran through his dreams and he woke more exhausted than he went to bed. But no matter how shitty he felt, each morning he made himself get up and stumble downstairs to shower. He went to the track. Had to maintain appearances.

After the third horse broke its leg, owners began to complain about the surface of the track, which was redone. A fourth horse went down, and its rider was thrown. He broke his neck and died in the hospital two days later.

Walter called. He wanted Billy to fuck both him and Roger. The two of them together.

"No."

Walter was upset. "Can I come over alone, then?"

Billy said no. It was over.

Billy went to the track. He parked his truck in the far lot. He wouldn't need his forge today. He was here to watch.

He stood in the stands and placed two-dollar bets on horses all afternoon. He was waiting.

"You've done so much for me," Billy whispered under his breath. "I wanted to give you a present in return to show my gratitude."

The gates went up. The horses took off. One horse nosed ahead of the pack. Then it was a neck ahead, half a body-length, a full body-length. The noise surging around Billy was tremendous, but he felt a hush of anticipation, a quiet center that cushioned him.

The lead horse suddenly fell. The rider fell. The horses behind trampled the jockey's body to a pulp.

Billy's face was carefully still. He turned to the man standing next to him and thrust his ticket stubs in the guy's face. "Dammit," Billy shouted, "that's the horse I bet on." He turned and left the stands, as if irate. But Billy was at peace. He knew he would have no more midnight visitors helping him make shoes.

This story seems to garner reactions in an inverse proportion to its length. People find strong resonances in it, or are incredibly offended by it, but few are apathetic to it—regardless of their own religious background and upbringing.

I won't say too much here, lest the introduction rival the tale in length, but I will remark that the story began with the image of the lesion, and symbolically the rest of the story just fell into place.

Calvinism

As I knelt before the crucifix, I couldn't help noticing that Jesus wore Calvin Kleins instead of a loincloth. I quickly stared down at the floor, embarrassed, but I stared up at His crotch again a moment later. I was curious if He hung to the left or the right. To my surprise, He had an erection, which was pointing down his left leg like a Muslim bowing down to Mecca.

It was so incongruous, I thought, staring down at the floor again but seeing His pale and wasted body before my eyes. His cock was swollen with desire, so vibrant, so alive, despite the debilitated state of the rest of his body.

I don't mean any disrespect, but He wasn't my type at all. I prefer a powerhouse of a man, well-built and with a chest like a barrel. But I wanted Him, Christ, wanted to feel Him inside of me, reaching, probing, filling me with His godhood. He wanted me, too. I could feel His eyes on me, and deep inside I felt a

sense of pride in my body, pleased that the Lord desired me. Was this pride sin? I wondered briefly. No, I decided, I was one of the chosen. The one He had chosen.

I looked up at Him again, and He smiled as our eyes met. I smiled back at Him, feeling like I could hardly believe my luck, like being in a bar and having the man I wanted want me back. He shrugged, a movement that looked as if He were lying in bed and had tried to rise. He stepped away from the cross, then crumpled to the floor, His limbs too weak to support him. I lunged forward to catch Him. Shame burned through me at the thought that I might have caused Him to harm Himself. I cradled His body against me, protectively, as if He were a child. He shuddered and shook uncontrollably for a moment, and I was overcome with a feeling of wanting to do anything to make His pain go away, to make Him well. But at the same time I could not help noticing the feel of His cock pressed against my leg, as the seizure twisted His body.

I helped Him to His feet, and He leaned heavily on me. One arm was thrown around my neck for support, the other outthrust in a wild gesture, pointing toward the confessional. The stigmata was plainly visible on His palm. I looked at it more closely. It wasn't a stigmata but a lesion, large and purple, making him look as if He were a scholar who had accidentally spilled ink into His cupped palm.

Before we had made it completely into the confessional booth He began reaching for me, His fingers weakly fumbling at my belt as He groped. I shut the door and then helped Him, undoing both the buckle and my zipper, letting my pants fall down around my knees. I was wearing a pair of ordinary white briefs and the head of my cock poked above the elastic band,

swollen with my own desire and anxious to get a look at our Lord. When I felt the first touch of His trembling fingers on my cock, even through the white cotton, a thrill ran through my body unlike anything I had felt before. I burned with ecstasy, feeling almost numinous myself. This is the Passion of Christ, I thought briefly, before the passion overwhelmed all thought.

Hardly able to control myself, I knelt before Him and tugged His underwear down. Freed from His Calvins, His cock rose, tall and majestic, a divine ascension. I paused as I bent toward Him, marveling that I was about to service Christ, son of God, who died in our stead, for our salvation.

"This is my body," He whispered, pulling my head toward him. I didn't mind His impatience; He had died to save me. I opened my mouth, and took His cock between my lips, letting it rest on my tongue like the wafer, tasting, savoring. His head rolled to one side as I began to work my tongue back and forth. Soon His mouth opened in a small gasp of pleasure. "And this is my blood," He continued, and came in my mouth.

Who has not, at some point in their life, dreamed of being able to fly? I know that I really feel comfortable in a place—having moved to a new city, a new home—when I have dreams of it from overhead, flying over the place where I sleep.

"Crow Feathers" was an exploration of both home and flight, written for Marion Zimmer Bradley's anthology Sword & Sorceress XIII. *I was always picking up feathers as a boy, when I'd roam the woods behind our house, scavenging interesting items like a magpie: a piece of wood that twisted just so, a special rock. In this story, all those cherished totems at last take flight.*

Crow Feathers

The fresh air almost made Ysabelle sneeze as she carried the heavy chamber pot out into the woods behind the inn. Spring was exploding all around her, flowers and buds and birdsong, and she was cooped up inside, dusting and working. It was her eleventh birthday, and she couldn't help thinking about how things would be different if her parents hadn't been killed in a raid last summer. Galen, the hostler, and his wife had taken her in, it was true—and an extra mouth to feed, especially just before winter, was no light burden to shoulder—but they certainly worked her hard enough in exchange. She did far more work than either of their natural daughters, that was certain, and always the most unpleasant of tasks. Ysabelle

116

remembered when her parents were still alive: at this time of year they would go out into the woods and have picnics, picking herbs and berries and wild mushrooms. . . .

"Ysabelle, you lazy wench, stop daydreaming and get back to work!"

Ysabelle startled forward. She wondered what would happen if she just kept walking into the forest and never returned. A crow floated lazily to her left, and she stared enviously after it, longing for wings of her own that would carry her away from her unhappiness.

She dumped the smelly contents of her load under a bush and headed back to the inn. At the edge of the forest she turned around for one last look at the green, burgeoning life. It seemed alive with energy and vibrancy, whereas the inn she returned to seemed as dark and unwelcoming as a dank cave. She looked up for one last longing glimpse at the crow, and as she watched it flew toward her. The bird flew in a tight circle above her head, once, twice, and on the third circuit dropped a feather down to her. Ysabelle let the pot fall to the ground as she reached to catch the ebon plume before it touched the soil. She smiled, and looked up at the bird, who flew off into the woods. She tucked the feather into her skirt, and hurried inside before Galen yelled at her again.

Ysabelle tied the feather around a string and wore it about her neck. It was a constant reminder for her of what life might be like elsewhere, and whenever she felt herself getting angry or frustrated she'd let her mind take flight, imagining she were flying overhead whatever had caused her disturbance, until she had calmed down.

She began getting more feathers. Whenever she saw a crow, it would fly overhead, circle three times and a drop a feather to her. Ysabelle saved them all, although only that first feather she kept around her neck. The others she stored in a small bag, which she kept hidden from her foster family, who would have thrown the feathers out if they found them—not to mention teased her mercilessly, if not beaten her outright with the switch. It took very little to make them use the willow switch on her. Her bed was in a corner of the attic, and she stashed the bag of feathers outside her window, under the eaves, crawling out there each night to add the new feathers. Ysabelle quickly had so many feathers she began stringing them together, ten to a strand, to keep count.

One afternoon, Ysabelle crawled out onto the roof to add a new handful of feathers to her cache. She normally did this only under cover of darkness, but she had been gifted with so many feathers when she emptied the chamber pots that morning that she was afraid they would be discovered. The innkeeper's daughters made a point of regularly inspecting her sleeping area, and immediately reported any faults or unusual objects to their parents, which invariably meant the willow switch was brought out.

Ysabelle was so afraid of being discovered up on the roof, however, that she moved too quickly as she scampered back toward the open window. She slipped, and fell off the roof.

Everything happened so quickly she hardly felt any fear of landing. Rather, she knew she was falling, and was more concerned that she would be in great trouble when she was discovered. She would make a terrible noise, she knew, and the whole family would be alerted and would come find her and she

would be punished. The feather around her neck came out from under her shirt, and instead of plummeting, Ysabelle glided to the ground, landing on her feet a considerable distance from the inn. She glanced back at the building to make sure that no one had seen this brief flight. No one had.

She knew she must return quickly, before her absence was noticed, but it felt so wonderful to be out of the inn, to be outdoors, free. The call of a crow caught her wandering mind, and Ysabelle watched three of the large black birds flying toward her. Ysabelle walked forward, almost instinctively, yearning to be among them. They landed on a fallen tree, and as Ysabelle drew near she thought she recognized the middle crow as that first crow who had dropped the feather she wore about her neck. The one, she noticed now, with human eyes.

"Corax," she thought, though she had never before heard the word. She assumed it was the crow's name.

Girl and crow stared at each other for a long time, gazes locked, until at last Ysabelle looked away. Once the contact was broken, the three crows spread their wings. Ysabelle silently thanked Corax as they lifted into the air and flew back into the forest. She watched them until they disappeared over the horizon, then tucked the feather back under her dress and hurried back to the inn.

Ysabelle began to weave the strands of feathers together, at night, working silently by the scant moonlight that came through her window while everyone else was asleep, and soon she had formed a cloak from the feathers.

As she grew older and came into her monthly courses, as her breasts began to develop and swell and hair to grow between her legs, Galen began looking for any excuse to tell her to lift her

skirts and bend over to be switched. He never touched her, at least not often, when his hand "accidentally" hit her instead of the switch, but as the blow was much less painful than the willow she didn't mind. Ysabelle knew she was switched often simply because Galen enjoyed looking at her naked and exposed. She felt unclean after every such incident, and thought often about running away; but where could she go? A young girl, alone, without family or means, she would be raped or worse if she left; at least here she was fed and clothed, if also overworked and beaten. It could be so much worse. . . .

It could be so much better, too, Ysabelle told herself.

One afternoon, after a particularly severe beating by Galen, she took the cloak of feathers she kept hidden under the eaves and walked out into the woods. She walked away from the inn, and as she walked, crows began to follow overhead, first one, then two, four, seven. . . . By the time she could no longer see the inn at all, if she had looked back over her shoulder, which she did not, there was a cloud of nearly thirty crows circling above her head.

They followed her through the forest, until the woods gave way to a cliff. Ysabelle sat on some rocks near the edge, overlooking the land below, green fields and a pool to her right, fed by a thin waterfall. The birds settled around her, and waited, uncommonly silent. At last, Ysabelle stood and untied the bundle. She flung the cloak around her shoulders and pulled the feather out from under her shirt.

She turned to face the birds. Again her gaze locked with a crow's human eyes. She heard the echo of a voice sounding within her head like her own thoughts, the same voice that had whispered "Corax" when she fell off the roof. "Come," the voice

said softly, moving like a gentle breeze across her mind. "Come with us. Fly with us."

"Teach me how," Ysabelle begged aloud, unaware how to answer with her mind.

"You are too heavy," a second voice echoed within her head.

Slowly, she stripped off all her clothes and left them folded atop the blanket. Naked, her wounds exposed to the light for any and all to see, she turned back to the crows, and thought, with as much strength as she could muster, "I am ready now."

"You are too heavy," the second voice repeated.

"Let yourself go," another crow said, hopping into the air to demonstrate.

Ysabelle jumped into the air in imitation of the crow, but fell back to the earth as she always had. "It's not working," she said out loud, forgetting in her frustration that they could hear her thoughts. Ysabelle met Corax's gaze, begging for help.

"Relax," said the crow's voice, echoing softly.

"Let your thoughts go.

"Let them drift among the clouds.

"Be free."

With a tiny corner of her mind, Ysabelle realized she was flying now, in the shape of a crow. She did not let herself worry about how she was flying, or why. She was too busy feeling the wind filling her wings and the sun on her back, soaring through the clouds and racing with the other crows.

When she had exhausted her first thrill of flight, the crows brought her back to the cliff where her clothes were. Ysabelle's human form returned to her as her thoughts ceased to soar and she remembered Galen and his family and the inn. The edges of the cloak swirled around her as she landed.

"You know how to fly now," Corax's voice echoed softly from within Ysabelle's mind as the flock dispersed.

She stared into the bird's human eyes and knew that he too had been human once, but had forever given up the form. Ysabelle considered, but she was not yet ready. She thanked him, and put on her human clothes, folding the cloak of feathers carefully. She would use it again, of that there was no doubt, but she was not yet free. She began walking toward the inn, of her own choice now, for there were matters left unsettled, and a leavetaking to be made properly, if not easily. Without that, she would never be free, and Ysabelle intended to be free. She was determined now to leave this ill-suited nest at last, and begin to soar as high as her strength would take her.

When the late Eric Garber told me, a few years ago, that he was editing an anthology of queer sword & sorcery with Jewelle Gomez, I decided to try my hand at a story with a sword. One of the aspects of fantasy that I find least interesting is weaponry. The intricacies of swordplay, the long detailed accounts of battles and carnage, the homages to the blade and the swordsman's life all hold such little appeal. I have a weak stomach for blood, and I have more often been the victim than the bully when it comes to physical altercations.

Eric mentioned that most of the other gay men's stories so far were very raunchy, and requested that I write something tame. So I decided to write a romantic quest to win a recalcitrant lover's heart. And a quest, I decided, needed a magical sword—even if I didn't plan to let him use it in the traditional fashion. (Too, a sword seemed such an obvious phallic symbol, perfect for a gay story.)

Heart of Stone

At the sight of the farmhouse, Javi's heart began to pound within his chest and, in his excitement, he tripped on a root and went sprawling to the ground. The lute he had cradled so carefully against his body went flying from his hands. Javi cried out, first in anguish as he flailed to grab hold of the falling instrument, and then in pain as his knee scraped against a rock that tore through cloth and skin alike. The lute banged to the ground and teetered forward and back on its curved belly. Javi scrambled to

his feet, wincing as he put pressure on his knee, and picked the instrument up. Aside from one broken string, the lute looked fine. He would just play everything but that string, he decided, hugging the lute against his chest and turning toward the farmhouse again. At the sight of it, all his troubles faded like mist before the morning sun and his heart began to race once more.

The heir apparent to Kolofell was twelve years old and madly in love with Brun, the son of a farmer who lived just beyond the castle walls. Javi's father, if he knew, would not approve, but Javi did not care. When he was two years old, his father had betrothed him to the daughter of a neighboring kingdom for political alliance, and so long as Javi married the girl next year and produced an heir, his father did not have a say in who Javi courted on the side. The gods knew, Javi had often enough stumbled upon his father in dalliance with one serving girl or another. Why should he begrudge his son the love of but one boy?

As he stared up at the still-dark square of Brun's window, imagining him lying abed, his dark-yellow curls spread about his face like a halo upon his pillow, Javi forgot the words to the love song he had spent all night composing and then memorizing, reciting it hundreds of times to his mirror by candlelight as he waited for the first ray of dawn. His mind was a blank.

Worried that they were forever lost, Javi looked down at the lute and tried anxiously to recall them. Something about his eyes, yes, and how for him Brun's words were music. Javi began to strum the lute softly, playing as if one string were not broken. Softly, so as to wake his love gently. Then, after giving him time to be awakened by the soothing music, Javi began to sing. He sang with feeling, loudly so that his words carried up to the

window his bold proclamations of love. Oh, how his heart ached when there was a rustling at the curtains! Javi's voice cracked with his longing for Brun, who was come to the window at last to acknowledge his suitor. Javi's voice rang with the overflowing emotion he felt, belting out the verses he had so painstakingly written.

The curtains trembled again and Javi felt his knees tremble in sympathy. The love of his life's form filled the window for a brief moment. Even so early in the morning, Brun's aim was true; the boot struck Javi on the side of his head, ending the song with a yowl of pain as he winced and dropped the lute again to clutch his boxed ear. Staring at the boot, Javi realized he should have serenaded Brun in the evening, instead of disturbing his rest. Brun was a farmer's son, who no doubt cherished his sleep after the full day of chores behind him and the one still to come. Fool! Javi berated himself as he bent to retrieve the token. Why hadn't he thought of that before?

He placed the boot on the doorstep so Brun would not have to sully his bare feet in the dirt to retrieve it. And, as if the boot were a crystal vase, Javi dropped two roses into its tall calf.

Whistling a phrase from his song, Javi turned to walk back to the castle and found Brun's father standing behind him. The farmer seemed tall as a tree as he loomed over Javi with a sour, pinched face. Javi hoped the man's displeasure was not because he had been serenading Brun; he imagined his own father's wrath if the king had been the one to catch Javi just now.

"Good day, sir," Javi said, trying not to show his surprise or nervousness.

"It's not a good day," the farmer replied. Javi felt suddenly concerned for his safety, and glanced about him. No one else was

in sight. He wished he could hurry back to the castle, especially before his absence was noted, but he and the farmer stood at an impasse. He seems a good, honest working man, Javi thought, trying to reassure himself. Perhaps he is not so closed-minded as farmers are said to be, Javi hoped. . . .

"It's not?" Javi asked meekly, when the farmer ventured nothing further.

"Indeed not. My plow is blocked by a huge boulder in my field. I was despairing that I had no way to remove it when I heard you singing. 'Another pair of hands,' I thought to myself. Come, it's not far."

Relieved that the man's displeasure was not caused by Javi's courting his son, Javi followed docilely behind, worrying how he could be of much help. This man dwarfed him in size and strength, and Javi's small addition of force would make no noticeable difference, he knew. But this man was Brun's father, and he wanted to make a good impression on him, that he might plead Javi's case to his son.

To Javi's dismay, the boulder was as tall as Brun's father and twice the man's height in width. "What use am I to move such?" Javi pleaded, as they approached the giant stone.

The farmer did not answer until they had reached the boulder. He set his hands upon it, as if he intended to roll the immense rock from the plow's path. "With the Stonesword, it could be chopped into smaller pieces, and thereby removed from my fields."

The Stonesword! Javi's mind raced with thoughts of his father's magical sword, that could slice through rock as if it were soft cheese. It was a powerful weapon, which Javi had touched only once. His father kept the sword well-guarded in the armory,

to keep it safe from all those who wished to steal it and misuse its powers. However, it wasn't being used for good at present, either, when its powers could be so useful to many of his father's people, in cases like the one at hand. He could ask his father, perhaps. But how would he explain his involvement with the farmer? Javi would have to explain, as well, about Brun and. . . . And Javi's father was as closed-minded as a farmer!

The farmer could see Javi wavering in his contemplation of the idea. "It would be a wonderful way to impress Brun," he said.

Javi blushed as his love for this man's son was so openly alluded to, yet he realized how true that statement was. He would be like a hero to Brun, using a magic sword to help his father. Javi could use the Stonesword to cut through Brun's stony heart toward him. He could borrow the sword from the armory and bring it back as soon as he was done. It's like a quest with no danger, Javi thought to himself as he told the farmer he'd be right back with the sword.

The castle was, as usual, abustle with activity. After being stopped twice on his way to the armory, Javi despaired of ever sneaking the sword out of the castle. He headed for the kitchen to try and sneak some food from the pantry as breakfast; it would be easier for him to think of a plan on a full stomach. And besides, he thought, it would be good practice for sneaking the sword out.

Marge found him sitting in the preserves pantry with a loaf of bread. "And just what are you doing in here, child?"

"Looking for a bit of privacy," Javi replied, wondering briefly if he should try to cover up the food, or if it was too late already.

"That'll be the day, when a stone pile this size gives you someplace to be private! I can tell you . . . well, you being the

Lord's son, I shouldn't say such things to you." She winked and turned to leave the preserves closet.

Javi stood up and grabbed her arm, having suddenly recalled that Marge's lover was the armory guard. "But that's just it, Marge. See, there's . . ." Javi opted for discretion as the best method of furthering his plan, "someone I've a fancy for. . . ." He stared down at Marge, letting this information sink in and also marveling that in the past month he had grown taller than her. "I was trying to think of a way we might have some privacy together. And I think I've just thought of one."

Marge stared at his smiling, smug young face for a moment, then demanded, "Well, what is it?"

"You're going to take me on a picnic," Javi declared.

Marge laughed. "You've a queer idea of privacy, child."

"You wouldn't actually go on the picnic with me. You'd just *say* that's where we were going. I'd cancel my classes, and that would mean no one would be using my classroom. You would be free to . . . spend some privacy with Venn."

Javi could tell Marge was seriously interested by the way her face became suddenly skeptical. "And what do you get out of it?" she asked.

Javi smiled, knowing she was hooked. "With no classes because of the picnic, I'm free to have some privacy myself." He puffed himself up to his full, if slender height, trying to keep a sly, knowing expression on his face, and accidentally bumped into the shelf of preserves behind him. Jars came crashing to the floor and Javi stared horrified at the spreading apricot puddle at his feet. "I'm—I'm so sorry," he stammered while Marge began laughing uncontrollably. "I'll help clean it up."

"Your face!" Marge giggled, "Your face!" Her body shook with laughter, and once the initial waves of mirth had passed she said, "Don't worry about these. I'll clean them up. You go cancel your classes and tell Venn to meet me in your classroom in half an hour. Then you and I will go on our picnic." She winked, then broke into another fit of mirth as she looked down at the puddle of apricots.

Javi pulled the sword from its sheath and admired its god-forged blade. It all seemed too easy, he thought, as he slid the weapon back into the scabbard and lifted it down from the wall. Venn had instantly run off to meet Marge as soon as Javi had mentioned the empty classroom. While Javi was grateful to be rid of him in order to sneak out with the sword, he was disappointed in his father's guard. Of course, Javi reflected as he wandered out into the hall, trying to walk as nonchalantly as he could while carrying the huge weapon, it wasn't like anything was going to happen in the middle of the castle. They hadn't been to war in years, which is why the sword had lain unused for so long. Javi's betrothal all those years ago had appeased Kolofell's last belligerent neighbor. But it was the principle of the matter; if anything, Javi's borrowing the sword might be an interesting prank to show how lax the guard had gotten.

So far the coast had been clear, but Javi heard footsteps around the corner, and the master-at-arms's voice. He'd never impress Brun if he got caught stealing from his own father! Javi ran back down the hall and dashed into the first door he could find. It was a storage room, filled with dusty crates. Javi had no idea what was in them, and he slowly poked around to keep himself from worrying about the master-at-arms outside in the

hallway, exploring his surroundings in the thin shaft of sunlight that entered the room through a high, iron-barred window. Staring up at the window, Javi suddenly had an idea for getting out of the castle without getting caught. He listened carefully for voices or footsteps outside in the hall, then pushed a crate under the window. He climbed atop it and stared at the gardens on the other side of the wall. It was empty. Javi smiled, and drew the Stonesword from its scabbard. He might be growing, but he was still very thin; he need only cut one or two of the bars from the surrounding stone to let himself wriggle through. Would he ever grow to have a body like Brun's? he wondered, envious despite the fact his slight frame would be so useful now.

Javi held the sword cautiously, regarding it in the dusty shaft of light and wondering if he would feel a tingle of magic as it sliced through the stone. He inserted the blade between the bars and slowly lowered it until it touched the stone. A loud hammering rang out, the rumbling of stone against stone, and Javi dropped the sword in alarm. The hilt fell against his foot, and the sword clattered to the floor moments before he fell beside it with a heavy thud against his backside. "The gods take—" he began to curse, before remembering that he was supposed to keep quiet and sneak out of the castle without attracting attention. The gods alone knew how many people had already heard him when he fell, not to mention the hammering sounds the Stonesword made when it cut into the wall. Javi stood, rubbing his aches and wishing life were simpler as he dusted himself off, wishing Brun would simply open his arms to him and accept him without all this wooing and effort involved. Although the wooing itself wasn't so bad. It was even quite fun,

and terribly romantic, which delighted Javi. It was just this particular quest which seemed to be going awry.

Javi climbed back atop the crate to inspect where The Stonesword had touched the rock. There was a thin, neat line carved a handspan into the stone—from just a touch! Javi smiled, and climbed down again to retrieve the sword. There was no way for him to silence the hammering sound as the sword worked its magic, he knew, but he would work quickly and hope no one heard him.

As Javi hurried past the farmhouse towards the fields where Brun's father waited, he glanced up at Brun's window. His heart fluttered in his chest with pleasure. There, in his window, was a pickle jar which held two roses! Javi could hardly refrain from singing his delight in a spontaneous serenade, extolling the virtues of Brun's beauty, his strength, and his loyalty. Javi's voice faltered momentarily as the curtains fluttered and he realized Brun was upstairs listening to him. But he sang on, ignoring the slight mishap. A moment later, the jar of roses was hurtling down at Javi. He ducked, lifting the sword to shield himself from the falling crockery. It shattered against the blade, drenching him in water and glass shards. Blinking in shock, Javi stared down at the broken vessel. The sword had sliced the stems of both roses in twain.

Attracted by the noise, Brun's father came walking towards him from the fields. Javi tried to dry his face on the back of his sleeve and make himself presentable before Brun's father came near. As he pulled his arm away, Javi stared aghast at his sleeve, now covered in splotches of blood, and realized that he had been sliced by the glass shards. He stared up at Brun's window,

perplexed that Brun could hurt him so, and therefore never saw Brun's father raise his hoe into the air and knock Javi over the head.

Javi woke to see Brun's beautiful face bending over him. He smiled and puckered his lips to accept a kiss, trying to raise his arms to wrap them around those beautiful, broad shoulders. Javi would feel so safe protected by those shoulders, sheltered in them; they would fit together so perfectly, Javi fitting snugly, comfortably inside them, as they nestled together. Brun slapped him across the face, bringing him into stinging wakefulness. Javi tried to lift his hand to his cheek, cradle it against the pain, but his hands were bound. "Behave," Brun commanded, as he fumbled with the ropes that bound Javi's hands behind his back. Suddenly Javi remembered bringing the Stonesword for Brun's father and the hoe coming down on his head and—

"The Stonesword!"

"Quiet," Brun commanded again, still working the ropes. Javi felt a searing sense of betrayal in the pit of his stomach; he had tried to impress what he thought was the love of his life, but Brun had been merely the bait to lure him with the Stonesword. Bile rose in Javi's throat and he swallowed to push it back down—a dry, dusty swallow that was of little help. Javi licked his lips, which felt cracked, trying to moisten his mouth as he contemplated what to do next and what his feelings about Brun were.

"There," Brun said, and stood, walking away from him.

Javi watched his retreating figure a moment. He still wished to be held by those arms, betrayal or none, and cried out, "Wait!" Javi pushed himself up on one elbow, and suddenly realized Brun

had been setting him free, not trussing him up. His heart lifted once again; Brun *had* been true to him! And Brun had saved him.

Brun paused. "He's probably still outside the castle walls," he said, flatly, "planning a way in." Brun turned away from Javi once more and disappeared inside the house.

Was Brun in cahoots with his father or not? Had he simply changed his mind? Javi couldn't tell. But at the moment, it didn't make much difference. He stood and raced back to the castle. No one else had any idea that it was even under attack, let alone that a god-forged weapon was involved. Which meant that it was up to Javi to stop the man. He would figure out Brun's involvement later on.

It was the sound of hammering that drew Javi to him, a familiar sound he recognized as the magic of the sword and not mundane construction as most people would assume. When was the last time any of them had heard the sword used? And who would suspect it would be used now? Against the castle itself, no less!

Brun's father was trying to break through the castle wall from the empty sculpture gardens. Javi had no idea what he was after. The treasury's gold? Or even Javi's father's life!

Forgive me, Brun! Javi thought, as he threw himself at Brun's father.

Javi was growing, but he still hadn't come into his full height and weight. Nonetheless, because the man wasn't suspecting anything, he fell to the ground, the sword flying from his grasp. Javi knew he was helpless against the farmer in a battle of strength, so his first instinct was to get up and go for the sword. He had nearly reached it when Brun's father grabbed his ankle and yanked him down to the ground. Javi continued struggling

to grab the sword, although he wondered, as he strained for it, his arm outstretched, if he could actually use it against flesh. He never got the chance to find out. Brun's father dragged him backward, then picked up the sword. He advanced toward Javi, the sword upraised, and Javi knew, deep inside, that this man wasn't going to question whether he could kill someone with the sword. Javi scrambled to his feet and bolted into the sculpture garden, Brun's father fast on his heels in pursuit. Javi wove between the marble sculptures, hoping to lose his attacker, but to no avail. He was running out of breath and could feel himself slowing down. If he didn't think of something soon . . .

Javi tripped and fell to the ground with a heavy thud. Goodbye, Brun, he thought. If only . . .

But he couldn't give up that easily. Desperately, Javi crawled forward toward a cluster of sculptures, hoping to use them as a shield. He stood, and peeked at Brun's father from under a marble arm. The farmer stood just on the other side of the sculpture, and Javi knew he was in desperate straits. Brun's father laughed and swung the sword. Javi saw the weapon coming towards his face and pulled back. The sword chopped effortlessly through the marble arm he had a moment ago been peeking from under. It fell to the ground. A hammering echoed in Javi's ears. In his distress, he had forgotten about the sword's magical powers! The sculptures would be of little use as a shield against the Stonesword.

In an effort to get away, Javi began circling back toward the castle, dashing from sculpture to sculpture. The Stonesword might be able to cut through the marble, but at least it slowed the sword down. Brun's father noticed where Javi was headed and blocked him off. They stood on either side of a tall, thin woman.

The sculpture was too far away from the others—if Javi ran to either side he would surely be wounded. They were at an impasse.

The farmer laughed again, a cruel, deep laugh, and swung the sword at the sculpture's legs. Javi jumped back reflexively as the sword swung toward him. The last barrier keeping Javi safe was now gone! In desperation, Javi ran forward and pushed the sculpture. The heavy stone toppled towards Brun's father and pinned him. Javi leapt over the fallen statue, grabbed the sword, and ran several paces off to catch his breath in safety. He turned to look at Brun's father, to make sure the man hadn't managed to push the statue off himself and attack again. The man wasn't moving. Javi wondered if it was a ploy to lure him close, only to grab him, but Javi couldn't help walking near to look. A puddle of blood was pooling beneath Brun's father. The white marble was splattered with red like berries against the snow.

Javi threw the sword away from him and fell to his knees. He had killed a man!

He was still retching when the guards found him.

Javi stared curiously at Brun, now on trial to determine his involvement in his father's plans. He wasn't sure how Brun felt about him for having killed his father, but Javi knew that he still loved Brun as desperately as he had before, if not more so. Javi had already given his side of the story, and been duly reprimanded for taking the Stonesword. He would be working off his punishment for years, it seemed, and his body was already beginning to ache from the mere thought of the labors he had been assigned by his father. His killing of Brun's father had been in self defense, it was determined, and in the defense of the castle.

Brun, it seemed so far, had had nothing to do with his father's plans, which heartened Javi. He didn't know how he would have dealt with this love he felt had Brun been implicated.

Javi's father was still asking questions, however, and Javi listened closely for Brun's responses. "You seem very coldhearted towards your father."

And me, as well! Javi wanted to cry out. But he hadn't mentioned why he had been out at the farmer's house when he told his side of the story, and kept quiet.

"And why should I be sorry to see him gone from the earth? I am glad to be free of him at last." Brun paused, looking around the circle of assembled men around him, meeting each of their eyes but pointedly not Javi's, before continuing, "Since my mother died, he would force me to lie with him."

Javi cried out, an inarticulate sound of frustration and outrage that rose above the surprise of everyone else. His father silenced the room and declared the trial over. Brun was not guilty, and would inherit his father's lands and possessions.

The sun hovered just above the horizon, balanced as if it sat, an orange globe, upon the earth. Javi stared up at Brun's window, and the soft light emanating from within. He brought the lute into position, its strings having been repaired in the long week since last he had seen Brun. Javi felt his love had needed some time to recover from the upheavals in his life, and Javi's part in them, and though it tore his heart not to see his beloved, Javi had waited until now before resuming his courting.

Javi sang hesitantly, unsure of his reception. He had given much thought about whether and how to proceed after learning of Brun's being abused by his father. He was so very much in

love with Brun that the thought of dropping their courtship was an improbability in Javi's mind. But he would proceed slowly, and with sympathy, slowly winning Brun back from the painful attentions of his evil father.

When nothing came hurtling out the window, Javi gained more confidence. He began to sing louder, letting more of his feeling for Brun enter the music. He knew Brun was up there because candles were lit in the room, and Javi's heart swelled with happiness simply to know Brun was listening to his professions of love.

Javi was on the penultimate verse before Brun threw something. His aim was still true; it hit Javi in the ear again. Javi stared down at this new token and broke into a smile. It may take a while, Javi thought, but I'm slowly wearing him down, eroding my way into Brun's stony heart. And I'm willing to wait.

Instead of his hard-heeled boots, Brun had thrown a soft, embroidered slipper.

Ironically, in all the years I've been writing for Marion Zimmer Bradley's Sword & Sorceress *series, I've never written about a swordswoman. As I said in the introduction to the previous story, swordplay holds so little interest for me. (A duel of rapier-sharp wits, on the other hand. . . .)*

Nonetheless, I thought I ought to try my hand at a swordswoman story, at least once, to prove that I could do it. And, in typical fashion, I approached the problem from an oblique angle, after the battle is over, the life of the mercenary in search of a purpose .

I gave the story to a magazine that was just starting up, Adventures of Sword & Sorcery, *who kept it for their second issue since they published a different story of mine in the first. So one of these days, I'm going to have to write a* second *swordswoman story, for Marion.*

An Oath of Bone and Velvet

Sylvia snored like a volcano: silences that stretched so long you thought it was finally safe to let your mind drift into the night, broken suddenly by an eruption of sound that startled you with its volume into wakefulness. I wanted to shake her and shout at her to be quieter or else, blood-sister or not, I would leave her behind. But I let her sleep. We'd been returning toward Sumbry for the past two weeks, and she was exhausted with the travel and post-battle letdown. We both were. Sylvia snored again, a sound

like collapsing timber or the grinding of heavy stones. At least one of us was getting some rest, I reflected, as I gave up and crawled from the tent into the moonlight.

Sylvia had that gift of being asleep the moment her head touched her bundled clothes. I had been having trouble sleeping ever since that last attack that had routed our army and ended our most recent job. Every time I closed my eyes I would see the Urdham swordsman's blade held above my neck, poised for a killing stroke, when Sylvia struck him from behind, her sword piercing through his chest to protrude toward me. I didn't know which had frightened me more: my own near death or Sylvia's efficiency and calmness as she slew a man to save my life.

I stood and stretched my limbs as I waited for my eyes to adjust to the night. How long would we be able to live this life? I wondered. And how long would we want to, making a living from death? I felt myself growing frazzled by the constant battle. But what choice was there? Fighting was all I knew how to do. I was too young to retire and teach swordplay to rich merchant brats, although the idea of settling down was appealing. But in the meantime, Sylvia and I would need a new assignment soon, to bring in some coin.

I looked about me with my new night vision, and froze as I saw nearby a stag, who regarded me with large, dark eyes. I admired the majestic arch of his antlers, bathed in moonglow as he stood poised for flight. We contemplated each other for a long moment, and then he turned toward the forest again. I felt privileged to have glimpsed such a shy and regal piece of nature. He began to walk, to disappear into the green, then paused and looked back at me. Did he not trust me, I wondered, or did he mean for me to follow? I wasn't sure, but the look in his eyes and

my own desires led me to guess the latter. I took a step toward him, expecting him to bolt into the woods, a flash of white tail as he fled. But he did not run. He turned his head back to the forest and slowly resumed walking.

I wondered briefly at his purpose as I followed him, marveled at the ease with which I trailed tamely behind so proud and elusive a creature. But my mind did not wish to dwell on such matters and instead concentrated on the beauty of the forest around us, the rippling of muscle beneath his flank as he led me deeper into the woods. The trees seemed even more lush in the moonlight, their branches so laden with dark green that they bent toward the earth.

The stag stopped, and turned halfway toward me. Behind his shoulder I could see a doe, lying on the ground, and as I drew nearer, the many arrow shafts protruding from her side and neck. I kept walking, the stag momentarily forgotten as I knelt beside her and felt for a breath of life or pulse. I could hardly believe such cruelty, that she had been shot simply for sport and wanton pleasure, then left to die and rot in the woods, to be torn to pieces by scavengers.

And then I saw the calf, still wrapped in its caul, behind the doe. She had been pregnant, and in her death had given birth to her calf. Or tried to. But the calf had been stillborn, or perhaps had suffocated in its caul, unable to struggle free of the clinging membrane with its too-young limbs. I felt sick to my stomach. The fighting of man with his fellow man was nothing new to me. But man, as a race, was not innocent; this cruelty toward nature, wanton and senseless, made my heart burn with anger.

I turned back toward the stag which had led me here, but he was gone. On the ground, a pair of antlers rose toward the sky.

They were warm beneath my fingers, the hard bone wrapped in velvet. I lifted them before me, admiring their many points silhouetted against the moon, then placed them upon my head.

Sunlight. The rush of trees. Labored breathing. A stitch in my flank. Kicks inside. Men. Men all around. Wild sounds. Raucous. Laughter? I could not think clearly, as I fled. PAIN! Pain in my back. Again. Ignore it. Keep running. Run. Must get to safety. The baby. . . .

I blinked against the vision of the antlers, the vision of the doe's death. The image of those young men, reckless and cruel in their sport, set my blood racing with hatred. I lifted a hand to my head and grasped the antlers. "I swear," I shouted up at the moon, "I swear by the bone and velvet of these antlers, by the trees that surround me and the earth beneath my feet, that I shall avenge this death." I felt powerful wearing the antlers, unweary, strong and fleet as the stag.

And for the first time in years I felt content.

I was now the forest's avenger, and it seemed to me a far better life than that of a mercenary. It felt more just somehow, more full of purpose. I was weary of the insignificance of being a mercenary. We fought and fought and fought, but the battles never changed much. There was always another battle going on somewhere for us to join. I was sick of the cheap price of human life.

Sylvia, I was certain, would understand. The antlers would convince her; they would give her, too, the strength of conviction. I reached up and touched their warm velvet-covered bone. We would settle down here, in the forest, and it would sustain us as we protected it. I knew, deep inside of me, that this was true, just as I knew, too, that we must eat the doe, that its

death not go to waste. My mind and body rebelled at the thought, bile rising high into my throat. But I blinked my eyes against the tears and swallowed hard, converting my disgust into a conviction to hunt down the men who had so carelessly killed within my forest.

My forest. That was how I felt already, mine by right of the antlers and my oath. But I was as much the forest's as it was mine.

I stood in the moonlight and felt the rhythm of the woods course through my veins, vibrant and raw. I had been transformed, I knew, transformed into a primal force of nature. A woman's body and spirit with the strength and horns of a stag.

And as I walked back toward Sylvia and our camp, I suddenly smiled. For with the antlers' power running through my veins I felt strong enough to endure anything, even the sound of Sylvia's snoring.

Writers Who Love Titles too Much. *That's the self-help book I need. I can't help myself. Sometimes a title is just too good to let go of, and then I'm stuck trying to figure out a story to go with it.*

This piece was a title I'd been saving in my files. (Actually, during my late teens I'd written it up as a piece of doggerel for a small press magazine, but I knew I'd eventually steal from myself to use it for a piece of prose.) Stefan Dziemanowicz and Robert Weinberg have been editing a series of anthologies, each containing one hundred short-short stories on a certain theme. When they told me they were editing a volume on witches, I didn't even need to check my files; this title kept flashing through my mind again.

I just couldn't help myself.

Coming Out of the Broom Closet

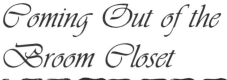

"I can't stand all these secrets," Robert had told him. "I feel you don't trust me. Hell, I feel I can't trust you. How do I know you're not having an affair behind my back? It certainly seems likely."

"It's not that," Eric promised.

Robert left him anyway, saying, "But how can I know? I can't live with these secrets anymore."

Now, everything reminded Eric of Robert. He was driving himself crazy with loneliness as he moped about the apartment they had shared these past seven months. Eric would suddenly notice something out of place—a gap in the bookshelf, his own battered old boombox where once Robert's fancy stereo had been—and the realization that Robert was gone would come crashing in on him once again. The fact that no one complained when he squeezed the toothpaste tube from the middle, complained and half-patiently, half-exasperatedly rolled the tube anew from the bottom each night. What had become Eric's favorite clothes were no longer in his closet, because they had never been his. It was all driving Eric absolutely berserk and there was only one solution he could think of that gave any hope for a second go at things. It was probably too late already to save their relationship, but Eric was determined to go through with it, as his only hope.

The time had come for him to come out—as a witch.

"You'd have thought it would be easier the second time," Eric confided to his reflection one morning, a week after he had begun to tell his friends, as he waited for the shower to warm up. "Coming out."

Gregg, who'd been Eric's best friend since sophomore year in college, had spewed strawberry milkshake from his nose when Eric told him. He apologized profusely, of course, when he saw that Eric was serious, but as he mopped up the spilled shake it only sent him into further paroxysms of laughter.

Eric sighed and stepped into the shower, lathering himself with soap. His friend Marilyn's reaction echoed in his mind, "I mean, everyone already knows you're a fairy, but aren't you

taking this joke a little too far? But while we're on the subject, how much would you charge for a jar of Love Potion Number Nine? I wouldn't need all that much, just enough to get Antonio Banderas to fall madly in love with me. . . ."

It was no joke. Eric couldn't see why no one understood that. In his anxiety, worrying over his friends' reactions to his news, Eric nicked himself with the razor as he shaved his leg. Staring at the blood, he was reminded of how it had gone when he'd told his parents.

His parents had been alarmed when he'd called them up and said he had something to say to them, to the both of them. But they didn't treat him seriously once they knew.

"At least it's not AIDS," was all his mother could say, repeating it over and over again, although whether to herself or to her husband or to Eric he was never sure.

Eric splashed water over the cut and finished shaving. Everyone had laughed at him. Eric wanted to cry. He tried to pretend it was just the shampoo in his eyes.

And to top it all off, Robert had already moved in with a short, Mexican bodybuilder he'd met at the Tunnel of Love. So much for salvaging that relationship, Eric thought wryly as he toweled himself off. Robert and he were supposed to still be friends, but Robert didn't have the time to be supportive of Eric's second "coming out," what with his new beau and all.

And I sure need all the support I can get, Eric told his reflection as he finished shaving the stubble from his chin. He powdered himself and pulled on nylons and a padded bra, followed by a black dress. Eric wished for the hundredth time that he and Robert were still together; it would make this all so much easier on him. He wondered if there weren't some love

potion he could make, to get Robert back, but all the love potions he knew how to make were het. Perhaps a bit of experimentation. . . . Switch the ingredients of. . . . But Eric was afraid to do anything that might hurt Robert. He was still very much in love with him, for all that Robert had left him for another man. Or left him and found another man. Same difference. Robert had gotten over him already. Maybe Eric would turn the bodybuilder into a toad. . . .

"You're stalling," Eric said aloud. He regarded himself in the mirror, wondering whether to bother, and deciding he'd better. He opened his medicine cabinet and began pulling down makeup: rouge, mascara, lipstick, eyeshadow.

Much as he dreaded the thought of it, if he was going to do this right, just as he had to come out to his friends and family and tell them he was a witch, he had to likewise come out to his coven, and tell them he was a man. Eric only hoped he survived the experience.

Having written "Femme-de-Siècle," I knew that at some point I would have to write a gay male vampire story. And I was nervous: could I come up with something that was equally as integral, both as a gay male story and as a vampire story. I was also nervous about how to deal with AIDS, since there are so many clichés about AIDS in vampire stories—it's an easy and obvious theme to address simplistically—and yet there wasn't any way I'd be able to avoid it and still be honest to my subject.

I'd recently joined the Chelsea Gym when I wrote this story. My workout partner is one of my editors. We always discuss books—my books, his books, my other projects, etc. I couldn't help wondering, as quarterly taxes had to be paid, if I couldn't deduct my gym membership as a business expense, since I did do so much business there. I figured that if I wrote some pieces set in the gym, perhaps I'd have a stronger case, claiming that the gym membership was a necessary and deductible research expense for the stories.

But even if I can't deduct my membership, I've grown to love this experience that's become so much a cliché of the urban gay male community. Since I'm a full-time freelance writer and editor, I'm home all day, writing or dealing with other people's writing, sedentary and cerebral. Going to the gym each day puts me back into my body.

I resisted joining a gym for so long. Where I live in Chelsea, Manhattan, there is a gym within a block in almost every direction from my apartment, and often a second gym within another two or three blocks. The gym is really so much a part of the gay "scene" in New York, and certain details of my gym just seemed so perfect for a vampire story.

And, of course, I couldn't resist the title.

Hemo Homo

Ever since I can remember, I've woken with a hard on. I'm sure there must've been a time when I was prepubescent and my dick was limp when I awoke. But since puberty, no matter when I wake up or how long I've been asleep, I've got a boner when I come to.

I don't know if it's just the exhilaration of waking, of finding out I'm still alive after the small death of sleep. I figure there might be something about that small death which links to le petit mort. At the least it makes for a cute joke.

Or it might just be that I have kinky dreams the moment I lose consciousness. REM libido. I wish I could remember some of them; it's as if my mind's a complete tabula rasa when I'm not awake for all the memory I have of them.

I think it's the first reason, though, since I never have wet dreams. I figure that if it were dreams causing my erections, I would sometimes get carried away and spill my seed before I wake. But that never happens. And every time I wake up, my dick has gotten up before me. I live in a curious half-terror that one morning I'll wake without an erection, although I'm not sure

why I'm so afraid of it. It was a relief that today at least I didn't have to worry about what I'll do if it happens.

I stroked myself for a while as I lay there, letting my mind wander through these and other topics. It always struck me as a bit odd that I could think about such philosophical issues when I was jerking off, but I liked the perversity of that. It made masturbation seem even more profound than I already believed it to be.

Eventually I stretched, cracking my back, and finally opened my eyes. The alarm clock's glow was the only light in my tiny studio. 8:47 P.M. Still early. I figured I'd head to the gym for a quick workout, and a quickie in the steam room, before starting my shift as a cabbie. I'm such a creature of habit, to the point where I almost fetishize the normalcy of routine. The gym was definitely a part of that fetishized jumble of habits.

Lately the "in" crowd has moved over to American Fitness, that great big subterranean complex of exercise equipment and such, with too much emphasis on the such—stuff like aerobics classes and a "health" bar and far too many heterosexuals cruising one another.

I'm still at the Chelsea Gym, if for no other reason than it's open until midnight, which better fits my schedule. It's also all male, and almost exclusively queer. Until something comes along to disrupt my inertia, it's where I plan to stay. There's something unpretentious about the gym with its two small floors of freeweights. It's top-heavy in its focus, because that's what most gay men want: big pecs and biceps. A decade into the AIDS crisis, it seemed so much of our sexuality was focused on looking, since people were so afraid to have sex with each other. I think gay men are getting past that now, in part because we're forgetting

about the crisis, having lived with it for so long it's become a constant. Or we're practicing safer sex or calculating risks or throwing caution to the wind and ignoring it.

But still the gym mania persists.

I think it's tied to the fact that you can't change the size of your dick—the vacuum pump ads all lie—but you can change the rest of your body, and insecurities being such a natural part of our psyches, we've become size queens about those muscles you do see in day to day life.

Of course, vanity and narcissism also play a heavy role, I reflected as I gathered my gym clothes into a knapsack. I flexed my bicep and thought how this—my looks, my body—helped me get laid. I went to the gym to keep these charms as best I could. I did also enjoy the endorphin rush of the workout, not to mention the rush from the sex in the steam room (not officially part of the gym, of course, but everyone did it and everyone knew it was there).

And part of me was concerned about putting on or at least maintaining my weight, in case the HIV ever got the upper hand.

Not that I needed to justify my going to the gym to anyone, myself included. Lately, however, I was reconsidering all of my actions. Which was another reason I went to the gym: it was a good place for me to think. When the body was occupied with some simple, repetitive task—like pumping iron or jerking off—the mind was left free to roam, the subconscious liberated as the front brain kept the body in motion.

It was a quick trip from my minuscule, fifth-floor walk-up with an airshaft view on West Twenty-fifth Street down to the gym, but I took my time, strolling lazily along Eighth Avenue and looking at the boys. A crowd of studmuffins on roller blades

lingered outside the Big Cup, while the throngs of men sitting in the window ogled at them through the glass as they sipped their cappucinos and iced teas. A towheaded blond walking a Dalmatian caught my eye as he turned the corner at Nineteenth, but I already had a destination I felt committed to and his pooch tugged him on toward home, so we merely locked gazes for a moment and chalked each other up as "the one who got away."

I made small talk in the lobby with Carlos, who was just leaving the gym as I got there. For someone like me who didn't hold down a normal job—as a cabbie, people came into my life in five minute intervals—the gym provided some social stability: that group of people I saw regularly, even though they weren't especially important in my life. They were one of my routines. I often looked forward to the gossip and interchanges, but when they switched gyms or moved to San Francisco or Los Angeles or (God alone knows why) Salt Lake City, there was always someone new to take their place. Their familiarity was comforting, reassuring in a way, like my waking hard ons. And these days I felt I needed all the comforting and reassurance I could get.

I felt at home here.

The Chelsea Gym was also the cheapest of any of the neighborhood gyms; even the Y on Twenty-third was more expensive. In fact, the only problem I had with the Chelsea Gym were the mirrors. Practically the entire place was mirrored, for the men to preen and pose and cruise while they pumped.

I'm always afraid someone will notice I don't have a reflection.

I try hard to make it less obvious, keeping some piece of equipment between me and the mirrors whenever possible, and ignoring their existence when I can't. So many men, it seems, don't actually work out but sit at one of the exercises and ogle

the other men in the mirrors. Which is an enjoyable pastime, I must admit, if a bit inconvenient for me. While I can watch them, they can't see me, so it's hard for me to cruise effectively, at least via the mirrors. So I pretend the mirrors don't exist as much as I can, and look at people directly when I'm cruising or interacting with them.

I gave my ID to Sam and went in. The locker room was crowded with naked men as the abs workout class (the Chelsea Gym's token semi-aerobic item) had just let out and they were hitting the showers at the same time that a chunk of the post-work lifters were coming upstairs from frolicking in the steam room and sauna. I loved to be in that whirl and press of bodies, but didn't linger long. I was studiously ignoring the scale over by the sunlamps, and then pretending to myself that I wasn't ignoring it and would weigh myself after the workout. The sooner I was out of the locker room, the easier it was to put out of mind.

I was working shoulders and back today. Generally I like to start with some rowing, vigorous exercise to get everything going, but both machines were occupied. I began with some front pull downs instead, grateful that all the machines faced inward, away from the mirrors. I had barely begun my first set when a stunning young boy I'd never seen before wandered into view. I stared at him, lusted at him, thought it was returned. I wondered if we'd run into each other down in the showers later, if he would tarry to wait for me or if I would hurry to join him.

For a moment, I grappled with the existential problem of loneliness: not just as a gay man, but as a vampire. What would it be like if we were to date, move in together, join our lives? I could share immortality with him.

It was a ludicrous fantasy, of course. I didn't even know this boy, had just seen him for the first time in my life, and already I was planning an eternity for ourselves! I didn't even know his serostatus.

It was natural, though, to want desperately to fill my life with someone else at the drop of a hat. "That is no country for old men," Yeats wrote of Byzantium, which must mean that Byzantium is now reborn in the current gay subculture. That sort of loneliness is even more cosmically acute for someone like myself, always destined to be alone, to outlive anyone I might know or love, to be constantly dependent on humans for nourishment.

My head turned to watch the boy as I continued my set. It was an appealing fantasy: the romance we might have, as much as the pleasure our bodies might take in sex.

I was procrastinating, thinking about so much else, and I knew it. I wanted to pretend everything was as it had always been, didn't want to face what was happening to me.

I'd been HIV-positive for at least a decade, with no adverse effects. I'm not sure when exactly I was infected, or even whether it was from unsafe sex or from drinking infected blood. Probably both.

There's a taste to infected blood that's different from anything else. It's like drinking lowfat or skim milk in some ways, thin and watery because there're usually few T-cells. But it's got an extra flavor from all that virus, richer in taste the higher the viral load. So infected blood is like drinking skim chocolate milk. I'm partial to the taste of it, but I try not to indulge too much, for a bunch of reasons. I'm less concerned about multiple strains of HIV, although with the changes now happening to me perhaps I

should've been more wary. Infected persons often have other diseases and afflictions, which I want to avoid. And perhaps most importantly, one of the ways that the HIV hasn't affected me is that, thanks to my vampirism, I am constantly replenishing my T-cell levels with the blood I feed on. So I stay healthy by drinking healthy blood. I do also feel guilty, taking the few remaining T-cells from people who're already losing them to the disease.

And thus I've been asymptomatic for at least a decade—maybe more, depending on when I was first infected. Until now.

I've begun losing my appetite, the first signs of the disease taking its toll on my body.

This terrifies me. I'm not replenishing my immune system with fresh, healthy blood and all that it contains.

And what frightens me even worse is that I'm afraid the virus is now attacking whatever it is that makes me, biologically, a vampire. The cellular changes that happened that night when I was drained completely of blood, and then restored with his blood, making me like him, a creature of the night. It wasn't at all scientific, although that's how I'm thinking about it now, since there's such a science surrounding the virus these days; it's how we're trained to think about it, in numbers and chemicals and not at all its devastatingly human effects.

I'd been able to ignore much of that techno-stuff, since my vampirism has been operating like an immune system, keeping me healthy from the HIV infection. Until now, when it seems a mutation of the HIV is attacking what makes me a vampire, my immune system equivalent.

And I've no idea what to feel.

The HIV might "cure" my vampirism. But the cure itself will kill me, since my vampirism is the only thing keeping me alive right now.

I'm not exactly discontent being a vampire, but I don't know if that's just because I'm so used to it now. I'd be happy to give up the bloodletting and the deaths. It's been a long time since I've killed anyone, though at first I didn't know how to stop feeding, how not to gorge myself past satiation, until I was bloated into a torpor—a dangerous state for me to be in since I so frequently had to flee the scenes of my hunger-crimes.

And as I, once-immortal, confront my sudden mortality, certain questions from my past began to recur: Did I have a soul? Was there an afterlife? Was I damned for all the lives I took to feed myself? Even though they were all in self defense, from my body's natural instinct for survival and self-preservation.

Would I again become mortal when I lost my vampirism, or would I instead die? But I was not alive now, I was undead. A quibble, perhaps, but an important one: I was not alive now, and I had once been dead. If I lost the state I was in, would I not revert to being dead?

And what would be the difference if I did become mortal? I'd sicken and die soon enough. I've never relished the idea of wasting away to this disease and being unable to die, on account of being undead already. I railed against the cruelties of fate, ignoring for the moment the fact that so many others had died before me and would yet die from this disease, men and women who would've killed for the prolonged years my vampirism had given me.

I'd been sitting blankly at the machine, lost in these reflections. That cute young boy wandered through my view

again, drawing my mind back into my body as my body began to respond to the sight of him, arousal stirring my cock within my shorts.

I stood, deciding to skip the rest of my workout, and followed him down the stairs to the locker rooms, and the showers waiting below.

I had no answers to any of my questions. And I did not know if there was anything I could do to change what was happening. I was hoping the exercise would increase my appetite, which might prolong my unlife some while longer. I did not, could not know what would come.

So I followed this boy, whose gaze met mine and in whose eyes I felt happy to be lost for all eternity, responding to those appetites which still lay within me.

I was somewhat surprised, as I was looking over the stories I had written in assembling this volume, at how certain stories echoed one another across the many years I've been writing—not to mention noticing specific phrases I'm overly fond of.

One surprise was that I had written two feminist werewolf avenger stories, though in very different settings and writing styles. This one was written for Marion Zimmer Bradley's anthology Sword & Sorceress X

In Sheep's Clothing

The rumor was handed to her at market, included free with her purchase: a wolf had been heard on the moor last night.

Balía thanked the fruitseller, tucking the rumor in the bottom of her basket among the cabbages and potatoes, to tell to Morfelao later. She placed the more delicate foods on top, pulled the cloth to keep them shielded from the sun, and continued on her way.

The wolf is not a solitary creature. Had a pack been heard Balía would have worried less. But a lone wolf was odd. A lone wolf meant shapechanger, human in borrowed form.

Balía had been given other rumors before. When she first came to Minagra, the townsfolk informed her that Morfelao was a sorceress, and her tongue cut out as a consequence, to still her

evil incantations. The women who worked in Morfelao's household told Balía that her tongue was silenced because she had been a heretic since her husband's death, and moreover, a persuasive one, thereby garnering the Inquisition's wrath.

To the townsfolk's dismay—for "she seemed such a nice girl"—Balía had accepted the post. What other work was there for a literate woman? Because she could not speak, Morfelao issued her commands by pen. No scriptorium would allow a woman to enter the grounds, let alone entrust one with a book. Yet, sometimes Morfelao would have Balía or one of the other girls read to her, just to have voices in her life. Furthermore, they were at liberty to peruse the library when the chores were done and they so chose. But the townsfolk did not understand. All they saw was superstition.

Should a single sheep be absent, or worse, a man attacked, the townsfolk would blame Morfelao the wolf. They would find her written notes and say, "Look! She has been writing curses. This is why my crop was lean. This is why there was no rain. This is why your horse dropped her foal early. We should have known. Burn her! At night she takes the form of a wolf! Burn them all! They have trafficked with devils." They would come with torches and knives, rope and cords of wood.

Balía shivered and left her basket on the counter in the kitchen for Fariel to deal with, hurrying upstairs to find Morfelao. She found the old woman at her desk in the study, pen still in hand as she stared blankly at the wall, absorbed in thought.

She had written: There is a wolf.

"How had she known?" Balía asked Fariel as she helped to mash the potatoes smooth enough for Morfelao to eat.

"A ewe was attacked last night. Korka found it, near dead, this morning after you'd left. Not sure why the wolf didn't kill. He tore a hind leg and left it."

"Does she live?"

"Keep mashing, she'll live. Though I can't say for how long. A lame sheep is easier pickings for a wolf, and she didn't give him much trouble the first time."

The moonlight seemed to find her eyes no matter what she tried, keeping her awake. Although frustrated, Balía lay still so as not to wake Korka, with whom she shared a room. Balía had tried everything she knew to put herself to sleep, but the most common way—counting sheep—merely increased her worry. She wanted to dash outside to the barn and count that they were all still there, especially the now-lame ewe. Even though they had locked them in for the night, Balía mistrusted that they were safe. She even began to slip from bed once, if only to stand at the window and look across at the barn, but Korka had rolled over, disturbed by her wakefulness.

Best not to go outside, anyway, Balía reflected as she stared up at the dark ceiling, realizing she should fear for herself as much as the sheep should she leave the safe confines of the house.

"Stocking up?" the fruitseller asked the next morning.

Balía blushed. "I forgot these, yesterday."

"Well, at least you don't have to worry about the wolf when you make that long walk. Against a lone girl. . . ."

"Was it—was it killed?"

"Yup. Shapechanger it was, too. Young thing, not more than ten or eleven. Just goes to show you can't trust anything in this world. They'll be burning the body this evening if you want to watch."

Balía did not want to watch. Her stomach folded in on itself. "A child," she whispered. "How could they?"

The fruitseller shrugged. "Three duros," she said, holding out her hand.

Most importantly, Balía and the others served as Morfelao's voice in the outside world. Balía had remained calm at the news of the boy's slaughter, and even as they paraded the body through the marketplace towards the temple. As soon as she had returned to the house, however, Balía broke down.

"A child," she cried to Morfelao, "a mere child. Innocent, too. He couldn't even kill our sheep, but resisted the impulses of his form." The bitterness in Morfelao's eyes was mute testimony that she could never underestimate human cruelty.

Balía fled from the house, and its human inhabitants, running outside to the barn where she collapsed in the hay to cry. She was roused by a nuzzling at her back and turned to find a sheep nibbling at her shirt. They had returned for the evening, still fearing a wolf in the woods, perhaps.

"The wolf is gone," Balía told them. "It is the human you must beware." They watched each other in silence as dusk advanced. To her surprise, Balía found that the ewe who had been attacked was nearly healed. In fact, the ewe seemed to heal further as she watched. Balía stood. What was occurring here? She moved closer, to inspect the ewe in what moonlight entered from the open barn doors.

Her wool was grayish, as if tinged with ash from the hearth. Or was it burning? Balía felt an intense heat radiating from the ewe. Her vision shimmered, like when she stared out at the plains on a hot summer day and the rising heat wavered over the grass, almost visible.

Looking down at the molten gray form below her, Balía knew suddenly what was happening. She, as human, must finish what the boy, as wolf, had been unable to. To let it live would be too dangerous. The ewe would not know what she did, when the lupine instincts took over and she attacked her own family and flock in the moonlight. The townsfolk would be riled from the first wolf, the shapechanger, and would love nothing more than to find that Morfelao harbored another.

But this is all that remains of that child, Balía thought. Could she really kill it? Especially when he could not. Must she so soon prove the truth behind her statement to the sheep to beware the human, not the wolf?

There was a compromise she could make, a compromise that would keep alive one small part of the child the townsfolk had killed. Without any hesitation Balía made it, reaching out for the wolf, one hand around its neck, the other inside its muzzle. She would avenge the child.

And now on those days when she goes into town and the fruitseller tells her a wolf had again been heard on the moor, Balía merely nods her head and smiles.

This is, perhaps, my most popular story. It has been reprinted more times than any other piece I've written, in any of the various genres I write in.

I had been living in San Francisco, on a semester's leave of absence from college, when the Oakland Fires took place. While I had been in numerous hurricanes growing up on Long Island, which knocked over many a tree on our street in addition to other wreckage, the Fires were the first truly terrifying and awesome natural disaster I have been witness to. I watched from a safe remove, across the waters of the Bay, but the totality and scope of the blaze wouldn't go away, even after the fires themselves were eventually extinguished.

Someone I knew was editing an anthology of erotic gay male science fiction and had invited me to submit a story. I wrote "Burning Bridges"—my first attempt at an erotic story—and she rejected it (although she did buy the second story I sent her.) Since I now had what I thought was a perfectly good story that was already written and ready to submit, I began to research the gay men's erotica market. I sent it off to the Mavety Media Group, which publishes a series of skin magazines, Playguy, Torso, Mandate, *etc. where it was bought by Chris Bram, who had been working there (under a pseudonym) for a few months as a favor to the editor in chief, Stan Leventhal. It was first published in the final issue of* Honcho Overload, *under my pseudonym David Laurents (an inversion of my first and middle names), and has since appeared in a handful of other anthologies and magazines.*

I don't know whether there's something about fires and eroticism (Lucy Taylor's haunting erotic story "In Heat," in Switch Hitters, *about a fire in Malibu comes immediately to mind) something about danger that adds an extra thrill to sex and sexuality, but I do know*

that this story seems to have a strong effect on people. Shortly after the publication of this story, I was at a dinner party where a friend announced, to the assembled gay men, that I was a pornographer. Naturally, this piqued everyone's interest, and they wanted to know if I'd published anything. I began to describe the plot of this story, when one of the young men exclaimed, "I read that!" and began reciting details.

I was astonished.

At the time, I'd never before encountered any nonwriter who'd read my work before meeting me. I was also shocked that he remembered quite so much of the story, able to quote passages from it even. It was my first experience of the power of pornography, as a genre of literature, and the pervasiveness of its consumption among gay men, a subject previously undiscussed amongst my circle of friends.

I've always been pleasantly surprised that my erotic stories, published in the pages of skin magazines, can have such strong impact on readers, who remember the stories months and years after reading them, when I meet them at cocktail parties, bars, wherever. So much magazine erotica is generic product, and any stories that work as fiction as well, that develop character and plot, stand out. And, what's more, because men are reading to get off and not for content, they accidentally absorb our morality—about intimacy, safer sex, monogamy, etc.—in a stronger way than generally happens if they're reading for this content.

In addition to the above reasons, I especially enjoy publishing in pornography venues because they are one of few vehicles where I can write as a gay man directly to and for other gay men, unapologetically, and without seeking acceptance or approval from the heterosexual über-culture. Writing, for me, is communication,

and even if the stories can and do also function outside of this context and are judged acceptable or are approved by the external culture, that's nice but it's not why I'm writing these stories.

As when writing for theme anthologies, I like to challenge the expectations of my readers when I write pornography. Most porn stories are encounters, where two (or more) men meet and have sex, in various permutations; I enjoy writing stories about men in relationships, who already know each other, that still work as porn stories. Or stories about butch/femme dynamics between men, challenging the stereotype of beefy guy boffing beefy guy. There is a tremendous variety within our gay subculture, and I think it's important to proactively ensure that this diversity is represented in our erotic literature.

And I think that erotic writing is tremendously important for gay men. We have an identity based on our sexuality, so the stories which explicity detail our sex are the stories which are concerned, most viscerally, with our chosen identities. Also, so many men learn about sex—what is done, and to whom—through porn.

I think "Burning Bridges" does work outside the context of pornography where it was first published. Because it was the first erotic story I wrote, it is in many ways a science fiction story with erotic elements rather than an erotic story with SF tropes (I've learned to be much raunchier in my porn!) which is why I chose to include it.

Besides, all porn is fantasy. Pornography is not sex; it is a simulation of sex. Pornography is a representation of the kind of sex the reader is not having, the kind they might like to have. One of the biggest fantasies in video pornography, of course, is that the beautiful body is the healthy body, which is so often not the case these days, more than a decade into the AIDS crisis.

But this is not the venue for this rant. (Although that's exactly why it might have impact here.) If you're interested in these thoughts, check out some of my erotic books, like Switch Hitters *and* PoMoSexuals, *both edited with Carol Queen, or various essays I've written for different anthologies.*

We now return you to our scheduled, erotic, and magical realist fantasy.

Burning Bridges

The bed was on fire! I jumped up, pulling the blankets with me. Reflex made my fingers shy away from the heat. By force of will, I grabbed the burning linen, flipped them over, and smothered the fire.

My heart was racing as I sat naked on the floor amid the smoldering bedding. The smoke detector still cried overhead. I forced myself to stand and reset it. I looked at the bare mattress and burnt sheets and stumbled into the living room, where I flopped down on the couch. I winced as I landed on my stomach; I still had a hard-on from my dream and had bent it in my landing. I wondered what I had been dreaming as I rolled onto my back and tried to fall asleep. In the early-morning light, I could see smoke still drifting from the bedroom.

I have a spark, a tiny flame inside my mind, like the spots that dance before your eyes after you've looked at the sun. Sometimes it gets loose.

I closed the lid of the toilet and sat. The ceramic brought goosebumps to my skin as I leaned against the tank, pressing up against it to absorb the cold into my shoulderblades, the small of my back. October and it was still as hot as August or July, the sun blazing during a drought. They promised me it never got this hot when I was thinking about moving to San Francisco from New York City. But then, a lot of promises had turned up empty, I reflected, as I stood and turned on the tap. I dipped a washcloth into the sink, soaking up the cool liquid. Elliott. . . . I held the cloth up to my lips, letting it drip against my neck and chest, cold. Elliott. . . .

I hadn't seen him in months. I had given up all that was familiar so I wouldn't see him at our favorite haunts in San Francisco. I know I didn't get very far (Oakland) but I couldn't bear the thought of being away from him. I was still madly in love. He had my new address and phone number, I knew, but I hadn't heard from Elliott since the night I walked out on him, when I found him in bed with another man.

I ran the towel under the tap again, and pressed it against the back of my neck, reveling in the feel of the cold, wet cloth.

My rage knew no bounds that night. It welled up inside me, a searing pain in my gut, burning like I was on fire. And suddenly my anger burst free, setting fire to items at random as I ran from the apartment. The thought of someone else making love to Elliott, other hands running across his body. . . .

I leaned forward and stuck my head under the tap, but the image of Elliott's body stayed before my eyes. I imagined they were my hands pressed against his flesh again and opened my mouth to nuzzle one of his large, dark nipples. I bit down on my shoulder, running the cold cloth down my body, between my legs. I cupped my balls, remembering the feel of his mouth on my cock, our bodies pressed together in ecstasy.

I grabbed the bar of soap from its dish and pressed it to my groin, rubbing it back and forth along the length of my cock until it had produced a lather. I remembered when Elliott and I had showered together the first night we slept together. He was in New York on a business trip. Was it two years ago, already? I remembered every detail: our first lovemaking, deliciously awkward as we explored each other's bodies, uncertain of everything but our desire for each other. I let the soap slip between my fingers into the basin, and reached for my swollen, lathered cock instead. I remembered the taste of Elliott's skin, the salt of his sweat under his armpits, his balls, the sweet flesh of his cock. I remembered the feeling of being inside him, the half-closed look on his face as he lay below me, his hands on my hips, pulling me toward him.

I could not hold back any longer and sat down, hard, on the toilet as I began to cum, shooting pale white arcs against my chest and stomach, legs. Beside me, the roll of toilet paper burst into flames. I ignored it, stroking my cock as it spasmed with pleasure.

I am lying in the top bunk. They are the bunk beds I had as a child. I look about me and find that I am in my room at home, except everything looks odd. I step on the ladder to climb down, when the rung

snaps under my weight. I fall, snapping each of the rungs as my legs push toward the floor. Am I grown so big, since last I slept here? I catch my breath, then lean down to pick up one of the broken ladder pieces. They are candy canes. I lick one to prove by its peppermint taste that I am right. This is what is odd: everything is made of candy.

I walk into the hall and hear noises downstairs, follow them into the kitchen. My mother is cooking. She is dressed all in black and has a big wart on her nose. On her head she is wearing a large, black witch's hat. "Good morning, dear," she says. "I'm making myself some breakfast." She points to the corner near the stove. "Would you like some?"

Elliott is chained to the refrigerator. He is naked, gagged, his hands and legs cuffed. I cannot help thinking he looks like he's ready for a B&D session, even as I open my mouth to protest. "You can't eat him," I say.

"What's the matter?" my mother asks, cackling like I have never heard her do before. "Don't you want to share with your mother? His flesh is sweet enough for you to eat, isn't it?" She crosses to where Elliott is bound. He tries to shy away from her, but the chains prevent him. She turns to look at me and grabs him by the balls. I know it hurts, because Elliott stiffens, his back suddenly hunched. "You eat his meat, don't you?" She shakes his flaccid penis for emphasis, violently tugging it. "You eat his meat all the time."

Suddenly, my mother throws open the door of the oven. It is enormous, like a huge, gaping maw. Inside, the coils are so hot that flames leap up from their orange filaments. I rush forward to stop her, but she throws Elliott into the oven and shuts the door. I try to open the door, but it will not budge. The light is on inside, and I press my face against the glass, desperate to at least see him one last time before he burns. Behind me my mother cackles on and on, her voice as high and nasal as a smoke detector.

I was choking, and bolted upright, coughing. A blanket of smoke covered the room. My spark must have gotten loose again, during the dream. Frantically, I looked about the room, wondering what was burning, and for how long; was I too late?

The smoke detector cried angrily overhead and I felt I just had to get out of there. I struggled into a pair of jeans, thinking as I did that this was no time for modesty, and ran down the stairs. Fire raged up and down the street. I cringed from the heat, awed and overpowered by the strength of my anger. What a dream of Elliott I had been having! Everything was on fire, from my block all the way to the Hills!

I felt my insides suddenly wrench with guilt. I had to make sure everyone got to safety. It was my fault if they died!

I heard shouts for help to my left. The neighbor's house was on fire, the roof crumbling in. I rushed into the building without hesitating, following the shouts. The heat was incredible, like standing in an open furnace. My jealousy-induced pyrokinesis was no help in protecting me from fire. All it did was cause damage, cause harm.

Even with Elliott. Elliott was afraid of my anger's spark. Afraid of me. That's why he hadn't called. He was too afraid to face what it meant, my love for him.

The shouting woke me from my memories. I rushed upstairs and into a bedroom filled with smoke. "Over here!" a voice shouted, "Help me! Over here!" I stumbled toward him. He was trapped beneath a fallen beam. I struggled to push it off of his legs. Come on, I berated myself, *lift*! You caused this fire! Adrenaline surged within me and I managed to lift the beam,

holding it on my shoulder as he scrambled out from underneath. I reached out with one hand to help pull him free.

"Get your hands from me, faggot," he shouted, swinging a fist at me.

I dropped the beam, ducking the blow. I felt a chill in my bones, as the adrenaline burning along my muscles froze.

"You're disgusting. Take advantage of a man trapped in a fire." He stumbled toward the door, turned and spat. "Pervert," then slammed the door behind him.

I was in shock. Why had I bothered? I had saved his life, and all I got in return was hatred. I wished for a moment that I had left him trapped beneath the beam.

No. This was all my fault! As full of hate as he was, I wasn't ready to kill him, wasn't prepared to be responsible for his death.

His, and how many others?

I saw Elliott's face before me, inside the oven. I tried to reach him, but the glass was in the way. I banged against it with my fists, but it would not budge. I cast about me blindly, looking for something, anything, to break the glass. My fingers closed on a pipe, and I swung it desperately at the oven, hoping I wasn't too late.

I choked suddenly, as I gulped in huge lungfuls of smoke. I stared blankly at the wooden door in front of me.

Elliott? Where had Elliott gone?

I was in the burning house. Elliott wasn't there. He hadn't been there at all, but was safe from the fire, miles away.

But I still heard his voice, calling for me.

"I'm coming!" I shouted, my voice tearing my throat. Panic surged through me; I had to get to him, save him from the fire. My spark burst forth, incinerating the door. I could feel the

care. I had to find Elliott, had to save him. I ran down the stairs, out into the street.

Where was he? I heard shouting to my left, turned toward my own apartment. I saw the man I had saved, ignored him. I could still hear Elliott calling my name; where the hell was he?

Suddenly, the door to my building flew open and Elliott was there, shouting for me. I rushed to him, practically threw myself at him. He held me in his arms, arms that were so comforting and familiar I couldn't help but believe he was real.

"You're safe," he said, hugging me so tightly my chest hurt. "I'm so glad you're safe."

I began to cry, an overflow of fear and frustration and happiness, and then passed out.

I could feel the flames licking at my skin. I was on fire burning up but I had to go on I had to save them this was all my fault I had to find Elliott I had to save Elliott!

And suddenly he was there with me, holding me, cradling me in his arms, shielding me from the flames. His hands were deliciously cool, draining away the heat.

"But we have to save them," I said, trying to push him away. "This is all my fault!"

"Shhhh," Elliott crooned. "You're safe now. Nothing is your fault. It was an electrical fire. Up in the hills. You had nothing to do with it. Because of the drought, it got out of control."

I stopped struggling. Electrical fire? Not my spark. Not my fault at all. I wanted to laugh with relief! I thought of the neighbor I had saved. Did I regret it? Risking myself for the sake of preserving his hatred?

No, I realized. I didn't.

I opened my eyes and looked at Elliott. His concern was obvious as he stared down at me, as he held me against him. I never wanted it to end, wanted to remain frozen in that moment, forever the object of his full attention. I was afraid that if I looked away, even for a second, everything would fall apart and I would suddenly wake up from a smoke-induced hallucination and find that I was still trapped in a burning building.

I could feel cloth beneath me, and finally I tore my eyes away from him to look at my surroundings. I was in Elliott's bed. In our old bed. Everything was as I remembered it. He hadn't changed a bit. I even pressed myself up onto my elbows to peer into the corner by the closet and laughed when I saw his dirty socks and underwear in a pile.

I lay back against the pillow again and closed my eyes for a moment, simply for the pleasure of opening them again to find Elliott before me. He really was there, holding me, running his cool hands along my body, draining the heat away. We were both naked. I wondered what had happened between the fire and waking up here, wondered if perhaps the last few miserable months had been nothing more than a nightmare. But then I coughed, my throat still raw from the smoke, and I knew that Elliott had found me in the fire, had brought me home and nursed me until now. I knew that he still loved me.

Tentatively, I reached out with one hand and pressed it against his chest, over his heart. His skin was as cold as marble, or perhaps I was burning up. I let my hand drift, luxuriating in the cool feel of his body as I explored its familiar planes, in the feel of his hands along my body, my chest, arms, thighs, draining away the heat. It was as if he was absorbing my spark, all my built-up anger and frustration. I surrendered to the sensation.

I sat up, pulling him toward me. My tongue was stone-dry as it entered his mouth, but he didn't care and, after a moment of kissing, it was soon wet. My hands ran up and down along his chest, which felt like a Grecian pillar, solid and safe; I clung to him. He pulled away for breath, and I kissed my way down his smooth neck and chest to his nipples, those large, dark nipples that had haunted my dreams. I ran my tongue around them, moving from one to the other in figure eights. Small tufts of hair grew in rings at their edges, the only hair on his smooth chest. I let my hands fall into his lap to his cock, swollen with desire and anticipation. His hands ran through my hair and down my back. I licked the strong muscles of his abdomen, working my way toward the sweet flesh of his cock. I felt his mouth wrap around my own cock, moist and tight. I wanted to consume him with my passion, to devour every last piece of him.

Unbidden, my mother's voice from my nightmare echoed in my mind as my tongue was about to touch his cock: *His flesh is sweet enough for you to eat, isn't it? Don't you want to share with your mother?*

I shook my head, trying to clear the voice from inside my skull.

Elliott sat up, concerned. "Are you OK? Did I hurt you?"

I looked into his face, at his loving concern, and felt there could be nothing wrong with the world. I pulled his head towards me, kissed him deeply, my tongue pressing far into his mouth. "I love you," I said, grinning like a baby from happiness.

He smiled back at me, and winked. "Likewise."

I laughed out loud. He hadn't changed one bit!

I turned and eagerly buried my head in his crotch, licking my way down his shaft to his balls. My tongue thrilled at the familiar

taste of his skin. I could hear Elliott's catch of surprise as I took one testicle into my mouth, which turned into an almost-purr in his chest as I began to suck on it gently. I let it drop from my mouth and rubbed my face back and forth along the length of his wet cock, letting it slide against my cheeks, eyes, chin, neck. With one hand I reached for his nipples, teased them with pinches and twirls. With my other hand I lifted his cock to my lips. Even his swollen, throbbing cock felt cool, inciting my own desire as the heat of my spark drained away.

I felt Elliott's mouth on my own cock, pumping up and down its length, his lips tightly clamped. It felt like he was going to suck the fire from me! We fell into a rhythm, in unison in sex, life, everything. I tried to hold back, to make the moment go on forever, but I crested over into orgasm, crying out in pleasure. A moment later, Elliott came, too, cum shooting up at me; I bent my face to catch his warm seed on my nose, eyelids, chin. He shuddered, and I felt an intense fulfillment that was soured by only one thing.

I looked about me nervously, wondering what my spark had set on fire. But nothing in the room was burning. I smiled, turned around toward Elliott, kissed him and held him tightly.

We walked down to the Embarcadero and stood together at the water's edge. The Oakland hills were glowing like coals after a barbecue.

I kicked off a shoe, let it drop, splashing water onto the reflected image of the flame. I stepped from Elliott's embrace and dipped a toe into the water, to prove to myself how cool it is, how wet it is, orange and red from the fire and the lights. I had to

prove to myself that I had escaped the flames as I had finally escaped my anger at Elliott.

I thought of my life on the other side of the Bay, in Oakland. I was perfectly happy to step back into the life I had left behind when I ran away instead of staying to talk. Life seemed so perfect right now, I never wanted it to end. It didn't have to, I thought. All I needed to do was forgive Elliott. He had proven himself when he came searching for me in the middle of the blaze. And he had forgiven me, for leaving him, for my anger, my dangerous spark.

To my left, three people conversed in French, leaning against the rail and smoking. Ash drifted before me, dropping to the water. One of the tourists laughed loudly and I began to shake.

Elliott put his arm around me and turned my face towards him. "Likewise," he said, and kissed me deeply.

When we came up for air, I focused on the tip of the tourist's cigarette, and let go of my anger, forever.

Our arms around each other, Elliott and I turned our backs and walked home.